IMAGES
of America

ESSEX MOUNTAIN
SANATORIUM

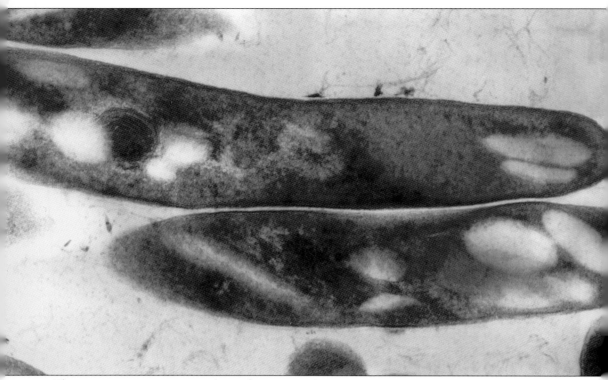

This is a microscopic image of *Mycobacterium tuberculosis*. Known as phthisis in ancient times, tuberculosis (TB) is nearly as old as mankind itself, having been discovered in human remains from the Neolithic era dating from 9,000 years ago. Around 460 AD, Hippocrates identified the illness, which involved fever and coughing up blood and was almost always fatal, as the most widespread disease of the times. Later known as consumption because of the long, relentless wasting that seemed to consume people from within, the epidemic in 17th-century Europe accounted for at least 25 percent of all adult deaths and lasted nearly 200 years. Often associated with vampirism and romanticism, it was believed to be hereditary in nature, with factors such as race, ethnicity, and social standing thought to play a role in the contraction of the disease. With the discovery in the late 1800s that the illness was contagious, laws mandating the segregation of the afflicted were introduced. Exposure to plentiful amounts of high altitude, fresh air, bed rest, and good nutrition were found to be effective treatments, and the sanatorium age began. (Author's collection.)

ON THE COVER: This photograph shows the Essex Mountain Sanatorium complex as it appeared in the mid-1930s, a time when tuberculosis took more lives than any other contagious disease in the United States. Positioned atop Essex County's highest elevation, the state-of-the-art facility boasted a 50-percent recovery rate and served the dual function of isolating the sick from the general population and forcing patients to live regimented hospital lives, assisting in the healing process. (Courtesy of Newark Public Library.)

IMAGES
of America

ESSEX MOUNTAIN
SANATORIUM

Richard A. Kennedy

ARCADIA
PUBLISHING

Published by Arcadia Publishing
Charleston, South Carolina

Printed in the United States of America

Library of Congress Control Number: 2012956240

For all general information, please contact Arcadia Publishing:
Telephone 843-853-2070
Fax 843-853-0044
E-mail sales@arcadiapublishing.com
For customer service and orders:
Toll-Free 1-888-313-2665

Visit us on the Internet at www.arcadiapublishing.com

For old friends and fellow explorers

CONTENTS

Foreword 6

Acknowledgments 7

Introduction 8

1. Genesis 9

2. Chrysalis 27

3. The Crown Jewel 53

4. Greetings from "the San" 71

5. Sanatoria 77

6. A New Hope 101

7. Death Throes 113

FOREWORD

It was a cold and solitary winter's day in the early 1990s on the top floor of the old Hospital Building of the forgotten Essex Mountain Sanatorium. Its windows had been shattered by vandals, and as the last rays of sunlight streamed through, the doors opened and closed as the wind blew down the hallway.

What is it about abandoned buildings that seems to draw the curious at heart? Perhaps it is the timeless beauty of the architecture built to last and the display of a certain grace. Maybe it is the connection to all the people they served and the shelter they provided to those in need in a time long ago, now preserved only in memory. For some of us, it is a connection to our proud heritage and a desire to keep the stories of these places alive so that we may never forget the contribution they, and the people who worked in them, made to better the lives of humanity.

Like myself, Rich Kennedy was drawn to this place. As he so eloquently noted on his website:

> I cannot explain why I felt such a connection with the sanatorium, or what had drawn me to it. They were, after all, just cold, empty, concrete buildings. But if you listened closely, you could hear the tragedy in the stories that echoed through its halls, and feel the despair in the distant memories that haunted its rooms. There was always a sadness I felt at the sanatorium. It was for all of the people who must have suffered there, and for the sanatorium itself. That despite all of the good it had done, and for the major role it had played in our history, it was condemned to linger, as a relic from the past, caught in a time where it was no longer needed. Sentenced to a long, slow, hard death that forced it to endure years of neglect and abuse that robbed it of its elegance and its dignity. A fate it did not deserve.

In this work, Rich has captured the true essence of the sanatorium—its buildings and its people. Although the buildings no longer stand, with this timeless tribute its proud and shining story will not be forgotten.

—Robert L. Williams, historian

ACKNOWLEDGMENTS

The author would like to express his sincere gratitude and appreciation to the following people who contributed to the creation of this book: Katie McAlpin at Arcadia; Verona historian Robert L. Williams for his knowledge, support, and advice; Linda Jehl, daughter of Dr. Wilbur F. Jehl, for allowing access to her father's amazing collection; Christopher Kynor, son of John Kynor, for allowing the use of his father's photographs; George Hawley, Tom Ankner, James Lewis, and Kathy Kauhl at the Newark Public Library; Chris Taylor and Frank DelGaudio at the Essex County Hall of Records; David Antonio at the Essex County Department of Public Works; Kenneth Bechtold and Bunny Jenkins of the North Caldwell Historical Society; Douglas Oxenhorn and James Amemasor at the New Jersey Historical Society; Nicholas Van Dorn at the Nutley Library; Frank Luca and Ivana Rodriguez at The Wolfsonian–FIU Museum; Jodi Koste at Virginia Commonwealth University; Theresa Trapp of the Hilltop Conservancy; Bill Minnich; Barry Lenson, son of Michael Lenson, for the photographs of his father; Carl Sposato; John P. McClellan; Anne G. Stires; Thomas J. Gartland; Michael Festa, Manuel Guantez, and Annmarie Tarleton of Turning Point; Susan Griffith of the Women's Club of Glen Ridge; Erika Gorder at Rutgers University; Eric Verbel for the laptop; Dan Greco of the Verona Police Department and the rest of the Verona boys: Gerard DiNola, Jeff Davidson, and Waxin' Jackson; William S. Wilson of Video Junkie; Mark Moran from Weird N.J.; Wheeler Antabanez; Veronica Kay; the old "asylum" crew: Bob Misner, Rob Walker, Dave Sharp, Steve Thompson, Mark Anderson, Dave Francis, Eric Koch, Rich Pater, and Rich Mazzola; mountainsanatorium.net contributors Mike Tomaselli and Emily Michelson; John Lefferts and the Jelloheads: MisterPat, Hidinginshadows, Mystryssovdeth, DaveC, Blondie, DemonicDreamz, Msterscary, and in remembrance of Theresa Kalos; Pauline Verona; a special acknowledgement to Della and the kids: Jeter, Boo, Pigeon, Axl, Midnight, Chico, and Jazmine; and my mother, who I know spent a sleepless night or two with my excursions to the hospital—you see Mom, it was all research.

Unless otherwise noted, all images included in the book are from the author's personal collection.

INTRODUCTION

It was spring of 1987. My friends and I were young, restless, and looking for a thrill. A friend's sister spoke of an abandoned hospital that was something straight out of a horror movie, complete with brains in jars, barbaric torture devices, and escaped lunatics that lived in underground tunnels and roamed the halls. She explained that the place had given her nightmares and that she could never go back, but she was willing to tell us how to get there if we were interested. Now, sound logic would dictate avoidance of locations where madmen purportedly hang out, but we were bored, suburban New Jersey teenagers with free time and beer money—she had us at "abandoned."

As we started up the long, deserted road that first night, lightning from a distant thunderstorm silhouetted the hospital on top of the hill, presenting us with the stark reality of what we were doing and where we were headed. Feelings of dread came over me as we approached the first building, and as we moved closer, the graffiti outline of a figure greeted us with the written message, "Waiting 4 U." It seems kind of silly now, but at the time it was extremely unsettling and very effective at setting the tone. We then headed to the main building and made our way up the endless flights of stairs to one of the large open roofs that overlooked the courtyard. From there, we could really take in the magnitude of our surroundings. The sheer size of the institution was breathtaking, and it seemed that in every direction we looked there were more buildings, each looking creepier than the last. And as we stood in awe of its desolate grandeur, the stormy rain came, and the complex came alive with haunting sounds of slamming doors and howling wind through broken windows.

I was terrified that night but also fascinated. I would return often, wanting to learn everything I could about the mysterious institution and the events that led to its fall from grace. From paperwork and files strewn throughout the buildings, I began piecing together what had happened there, which is now presented to you on the following pages of this book.

One

GENESIS

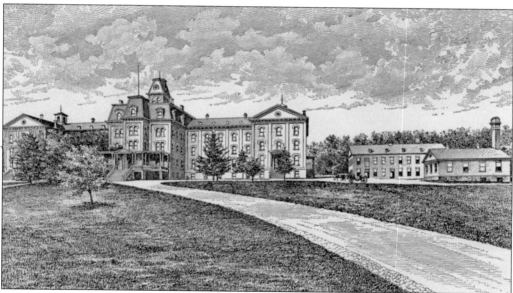

Essex Mountain Sanatorium's story begins with the Newark City Home (pictured), which was established in Verona, New Jersey, in 1873 when the 56-acre farm of Henry Walker was purchased along Gould Lane (later Grove Avenue). A classic example of Victorian architecture, it consisted of a three-story main building with mansard roof and cupola and was connected with both north and south wings. Constructed on the eastern slope of the second range of the Watchung Mountains, it was the largest building in the Verona Valley at the time. (Courtesy of Newark Public Library.)

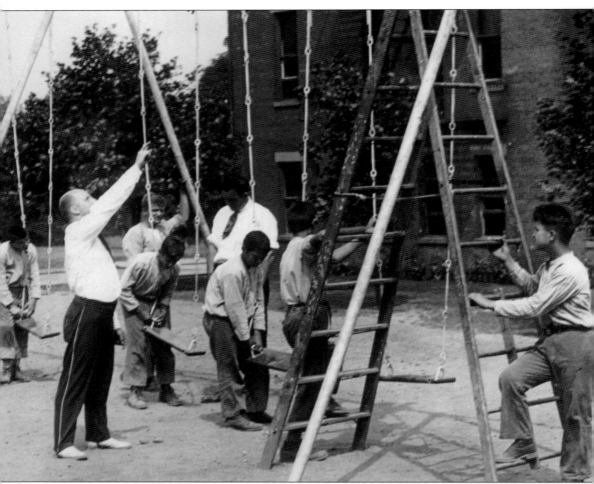

The purpose of the home was to both reform the children of Newark who "were treading the downward path" and to serve as an orphanage. The children were referred to as "inmates" and were enrolled in both academic and industrial training, requiring them to spend a certain number of hours a day in school and a certain number working. Unless paroled, inmates were expected to stay until the age of 21. (Courtesy of Newark Public Library.)

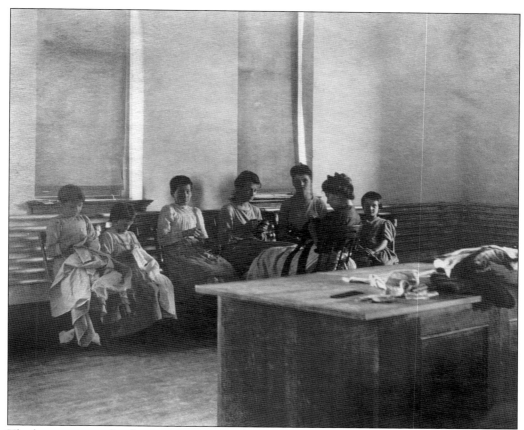

The boys were taught classes in printing, tailoring, carpentry, and brush making, while the girls (pictured) learned to sew, worked in the laundry and bakery departments, and studied music and drawing. There was an orchestra, a choir, and even a baseball team made up of City Home children. The institution also had a large farm, which was cultivated by the inmates, both male and female. (Courtesy of North Caldwell Historical Society.)

A controversial form of punishment at the City Home was the "electric cat," which involved a child being led into a dark chamber and having an electrode applied behind the ear at the base of the skull. A second electrode, in the form of a lash consisting of about 60 five-inch-long hairlike wires, was connected to a medical battery. Current was turned on, and the lash was struck on the bare back in quick succession; it was, essentially, an electrified cat-o'-nine-tails. The practice was said to have had "flattering results" and never needed to be repeated on the same child.

BAD BOYS ELECTRIFIED.

New Method of Punishing Incorrigibles at a City Home.

Newark, N.J., March 30.

A new method of punishing the inmates of the Newark City Home, at Verona, has been introduced and with flattering results. The incorrigible boys and girls, instead of being whipped, are electrified.

It is a very simple way. The boy or girl misbehaves and is led into the dark chamber. Then an electric punishment takes place, only the victim is not killed, merely shocked into behaving himself. An electrode is put behind the ear at the base of the skull, another electrode is placed at some other part of the body, a current of electricity is turned on and the victim howls with all his might until the punishment is over.

The vicious lads and lassies, and there are a good many of them among the 300 inmates, are generally touched up with an electric cat-o'-nine-tails. This is made of about 60 hair-like wires five inches long. When a boy has an electrode on his neck and an electric cat-o'-nine-tails is touched to the bare back, it makes the lad howl every time. Superintendent Harrison is well pleased with electricity as a means of punishment.

Daily Advertiser.

NIGHT EDITION

·DNESDAY, JANUARY 10, 1900.--FOURTEEN PAGES.

For Thursday, Fair and Colder, High Northwest Winds.

TWO CENT

NEWARK'S CITY HOME DESTROYED BY FIRE.

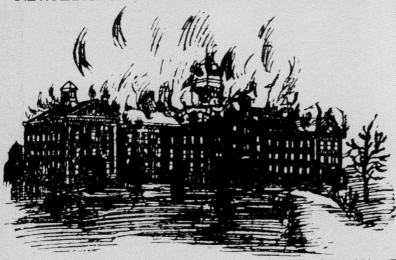

The Newark City Home at Verona was totally destroyed by fire last night. The children all escaped injury. The boys helped in the efforts to put out the fire, but the rotted fire hose was worse than useless. The total damage will be about $100,000. The city carries $80,000 worth of insurance on the place. The children are now being cared for at the Branch Hospital for the insane at Overbrook, at the Penitentiary at Caldwell, and at several other institutions, and Mayor Seymour is making strenuous efforts to have them all cared for until a new home can be built.

THE CITY HOME IN RUINS

Completely Destroyed by Fire.

LOSS WILL TOTAL $100,00

Children All Escaped, Marchin Out of the Burning Building in Good Order.

On January 9, 1900, a fire began in the cupola of the Newark City Home at about 4:00 p.m. An engineer from a passing locomotive on the nearby Erie Railroad sounded his whistle to warn the residents of the burning building, who were, at the time, preparing for supper. The inmates were marched out of the home in good order, with none of the 182 boys or 18 girls being injured. Although there was no loss of life, the main building of the institution was completely destroyed by the blaze, with a total loss estimated at $100,000. Some of the boy inmates were put on limited parole and sent back to their homes, while the girls were placed with local families and farmers. The remaining children were provided shelter at the insane asylum at Overbrook and the penitentiary in North Caldwell until more long-term housing solutions could be arranged. Days later, the former convent building of St. Dominic Academy in Caldwell was secured as temporary quarters for the boys, while the old Rogers house in Verona would become an interim home for the girls.

The fire—which was probably caused by overheating of the bakery flues that exited through the roof, near the cupola—burned so slowly that nearly all of the home's furniture could be saved. Eyewitness accounts state the fire was so hot that the brick walls became white, presenting a "brilliant spectacle." For hours, thousands of residents from the nearby towns stood along the surrounding mountaintops, watching the burning building.

At the time, Verona had no fire department, and the home's fire apparatus consisted of 12 extinguishers, a hose, and a water tank containing 7,000 gallons, which was located on a floor below the fire and rendered useless. A line of 75 boys formed to begin a bucket brigade, but they were no match for the flames. Montclair's fire department would respond but were told hoses were not necessary and to only bring ladders. They did, however, succeed in saving the other buildings (pictured) on the property. (Courtesy of Newark Public Library.)

NUMBER 5,045

Third Edition.

FLAMES DEVASTATE NEWARK CITY HOME.

Big Reformatory Building at Verona Almost Totally Destroyed by Fire.

INMATES ESCAPE IN SAFETY.

Not One of the Two Hundred Children Sustains the Slightest Injury In Leaving the Structure.

ENGINEER SOUNDS A WARNING

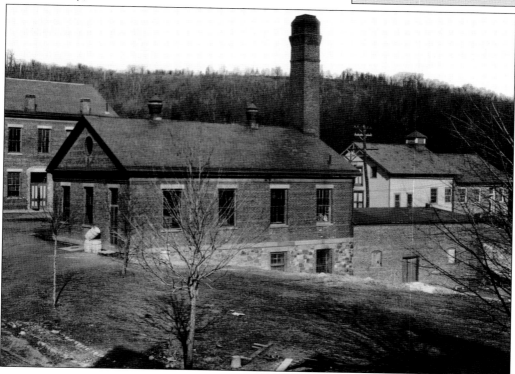

Although City Home superintendent C.M. Harrison (pictured) claimed that all of the children had been accounted for, various newspapers reported that anywhere from 3 to 25 inmates had taken the opportunity to escape custody during the fire. The following day, three missing boys were spotted on nearby Bloomfield Avenue and were quickly recaptured.

On January 12, three days after the fire, Mayor James M. Seymour (pictured) and the City Home Board of Trustees convened in Newark and decided that the mass housing of children in one structure was unsafe and that the rebuilding of the institution should follow the "cottage plan," modeled after the Glenn Mills Reformatory in Pennsylvania. Under the plan, boys and girls are segregated into separate cottages and grouped into "families" consisting of not more than 50 children. (Courtesy of Newark Public Library.)

Future cottage sites were chosen, and on October 30, 1900, ceremonies were held at the new locations, dedicating the lands. Special trolley cars conveyed officials and guests from Newark to Verona, where stagecoaches waited to transport them over the mountains. At 3:00 p.m., proceedings began for the girls' home with an overture by the City Home band, followed by Mayor Seymour formally laying the cornerstone. The invitation at right was placed inside the stone that day and was retrieved sometime in the early 1980s. (Courtesy of Verona Public Library.)

Newark City Home.

Verona, N. J., 1900.

Dear Sir:

You are cordially invited to attend the laying of the corner-stone of the Girls' Administration building and also of the boys' cottages, at Newark City Home, Verona, on Tuesday afternoon, October 30, 1900.

C. M. HARRISON, Supt.

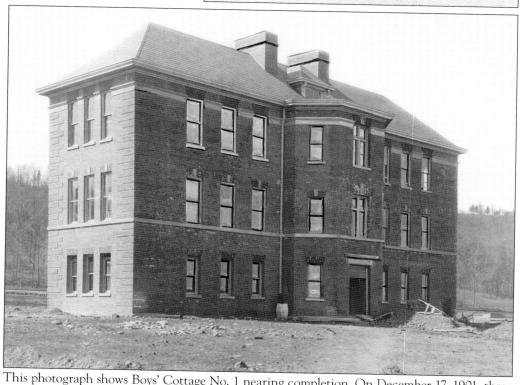

This photograph shows Boys' Cottage No. 1 nearing completion. On December 17, 1901, three new City Home buildings were dedicated and opened for inspection in the presence of the mayor, city officials, and invited guests. After the ceremony, a stagecoach carrying eight men and a driver started from the new girls' cottage to catch a trolley car. While descending the mountain, one horse became unmanageable and overturned the coach, ejecting and seriously injuring the passengers. (Courtesy of Newark Public Library.)

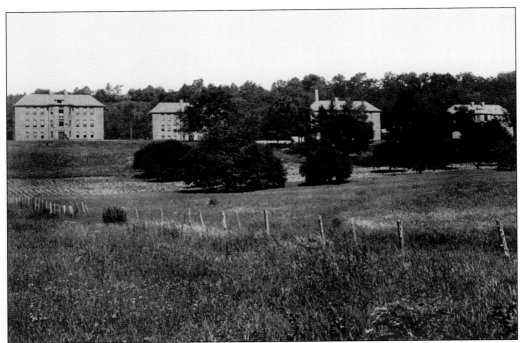

Like the original home, the new buildings faced east, toward Grove Avenue. Each cottage would house approximately 50 children and have its own master and matron (the exception being the girls' home, which only had a matron). The cottage to the far right was used as the Administration Building. Other structures on the site included a slaughterhouse, a smokehouse, and a cow barn. (Courtesy of Wilbur F. Jehl, MD.)

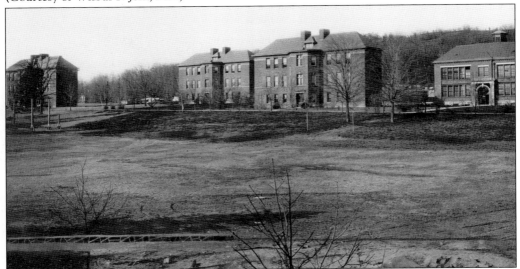

The numerous cottages of the rebuilt Newark City Home occupied over 100 acres, now the site of Verona High School. The open meadow in the foreground of this image is where the original home stood; it is roughly the location of the present-day Thomas J. Sellitto athletic field, which is plagued by sinkholes from unstable fill. In 2012, a shaft, three feet in diameter and leading into a man-made structure, was discovered beneath the turf. (Courtesy of Newark Public Library.)

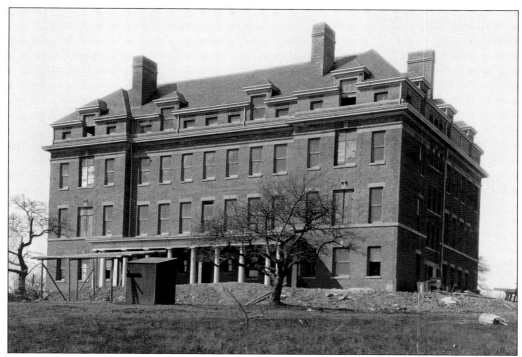

The Newark City Home for Girls was built on the crest of Second Mountain in Verona, at a site roughly a quarter mile northwest of the boys' cottages. Designed by architect Henry J. King, it was unique amongst the other cottages with its simple, "institutional-style" Victorian woodwork and several bands of carved brownstone and decorative keystones over each of the four major front windows. (Courtesy of Newark Public Library.)

The building was completed and opened in December 1901, but the number of delinquent girls was small, and in most cases, homes for them could be secured in private families. After receiving no girls in 1905, the cottage was phased out, and plans were made to transfer the property to the Department of Poor and Alms for use as a home for the destitute. Local opposition to the deal stalled the process, and the building sat dormant. (Courtesy of North Caldwell Historical Society.)

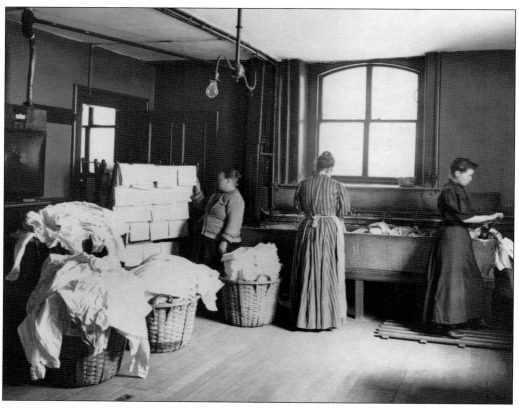

In February 1907, one of the laundresses working for Mrs. Edwin A. Prieth, an affluent and charitable woman from Montclair, had a husband acutely ill with tuberculosis. Being that he was poor and a resident of Newark, Mrs. Prieth and her neighbor Mary Wilson offered to pay for hospitalization and applied to the city's board of health for assistance in caring for the man. (Courtesy of Library of Congress.)

Dr. Herman C.H. Herold (pictured), president of the Newark Board of Health, was sympathetic but explained the city was not equipped to care for consumptive cases among either the indigent or those who could afford to pay. He detailed the appalling conditions of the few tuberculosis patients under the board's care, and when the women investigated Dr. Herold's claims, they found a young man dying alone in the basement of a downtown restaurant, with no money or food, his only bedding a board of health blanket. (Courtesy of Newark Public Library.)

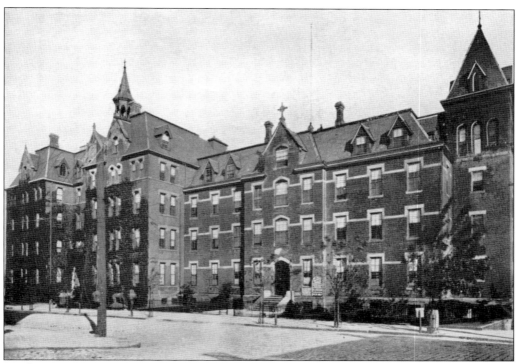

At that time, the only two institutions in the city of Newark that would admit tuberculous patients were St. Michael's, above, and the City Hospital, below. The Home for Crippled Children would receive bone tuberculosis patients but not people suffering from the pulmonary form. After attempting to secure a bed for the man at one of the few hospitals that accepted consumptive patients who could pay for treatment, Prieth and Wilson were presented with a waiting list. With at least 3,000 cases of tuberculosis in the city and 842 deaths from the disease, the board of health was helpless to cope with the growing epidemic unless an adequate facility could be provided. It now became a question of where. (Both, courtesy of Newark Public Library.)

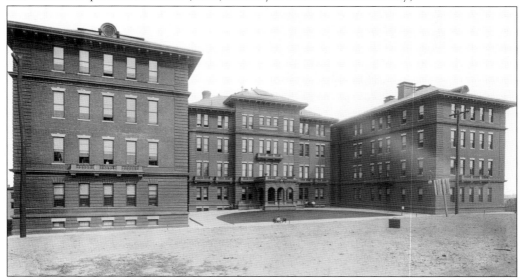

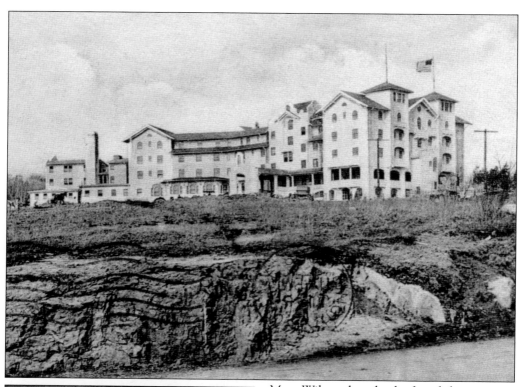

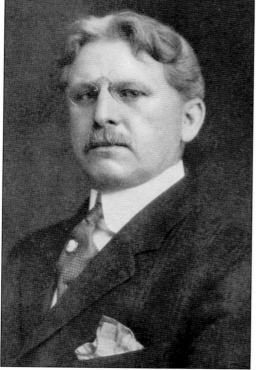

Mary Wilson thought she found the answer as she walked along the ridge of First Mountain, near the Montclair Hotel (pictured). "Looking across the valley, my attention was suddenly held by the glorious colors of the evening sunset as reflected in the windows of the abandoned girls' home. Like an inspiration the conviction came. The building is unoccupied. It is owned by the city. The location is ideal. Why not?" (Courtesy of Robert L. Williams.)

Under the direction of Mrs. Prieth and Mary Wilson, an appeal was made, and health officer David Chandler (pictured) and Dr. Herold went before the Newark Common Council with the proposal to transfer the building and 15 acres of land to the board of health for its use as a sanatorium. It was stated that discovery of the vacant cottage was "like finding diamonds," and when asked about the desirability of the location for the treatment of tuberculosis, Chandler replied, "It is splendid. In fact, Caldwell is now considered to be next to Denver for beneficial results." (Courtesy of Newark Public Library.)

The meeting was successful in winning support for the movement, and the city council was directed to "prepare such resolutions, motions, ordinances, or even legislative bills, as might be necessary to have approved, to transfer the building." Mrs. Prieth and Mary Wilson both appeared in Trenton, and Assembly Bill No. 384 was introduced. Assured there would be no opposition to such a worthwhile effort, the women returned home. (Courtesy of Morristown Public Library.)

Weather to-morrow : Probably fair and colder; variable winds.

Newa

NUMBER 7,247 NEWARK, N. J.,

CITY MAY HAVE A SANITARIUM

Initial Action to Convert Cottage at City Home Into Tuberculosis Hospital.

TWO WOMEN START MOVEMENT

They Appear Before Health Board. After Taking Steps to Clear Way for Turning Building Over to that Body, And Effectively Plead Cause.

In 1907, women were considered "moral guardians" of the home, and their appearance before a governing body was still a rare occurrence. Women's suffrage had yet to become a mass political movement, but many women were becoming a driving force behind Progressive Era reforms, significantly impacting the lives of countless Americans. As the legislature was nearing adjournment in Trenton, Prieth and Wilson telegraphed inquiring as to the fate of their bill. They were told, "Oh that—it's dead." (Courtesy of Library of Congress.)

TWO FRAIL WOMEN ROUT FIVE HUNDRED WISE MEN BY HARD WORK

THEY GET VERONA SANATORIUM BILL THROUGH

WHIP SOLONS TO A STANDSTILL

Under the impulse of an appeal made in the name of indigent consumptives by two charitable women of Montclair, the Committee on Municipal Corporations took formal motion in the launching of a project for the establishing of a municipal tuberculosis sanitarium at the building and grounds formerly used for the girls' department of the City Home but in disuse for more than a year past. The committee instructed President Herold and Health Officer Chandler to

The two women hurried back to Trenton and learned that Verona property owners were objecting and that word was out to "kill Assembly 384." They were even offered a bribe to drop their interest. Undeterred, they spoke with every member of the Committee on Municipal Corporations, pleading their cause. The intensive campaign finally succeeded in getting the bill before the House, where it passed by one vote.

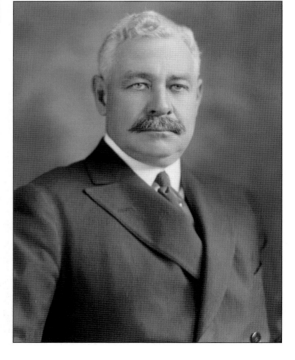

Although it was a victory, local protests were organizing back in Verona, and once again the bill was "lost." By this time, however, the two women's persistence had won them friends in high places. With the help of Sen. Joseph Sherman Frelinghuysen Sr. (pictured), the entire senate pledged their support to them. When Bill No. 384 was once again "found," it passed unanimously. (Courtesy of Newark Public Library.)

At midnight, Mrs. Prieth carried the bill to Gov. Edward C. Stokes (pictured), who signed it and sent the pen that was used back to Mary Wilson in Montclair, where she had been called home due to illness. In her last interview before she left Trenton, Mrs. Prieth stated, "This is the beginning of a great crusade in which all cities must one day join." It looked as if the city of Newark would at long last get its tuberculosis sanatorium. (Courtesy of Newark Public Library.)

Opposition had not yet subsided, however, and despite earlier assurances by City Home trustee Joseph Goetz (pictured) that they would "gladly turn the girls' cottage over to the city for a sanatorium" and "that there [was] no legal obstruction to the turning over of the building," the trustees abruptly informed the board of health that they wished to retain their right to resume control at any time. (Courtesy of Newark Public Library.)

23

VERONA HOSPITAL FIGHT.

Assemblyman Votes to Oppose Newark's Tuberculosis Sanitarium.

A curious sequel to agitation in Newark is the introduction of a bill by Assemblyman Samuel S. Taylor, of Ocean county, to make it unlawful to construct or maintain any hospital, sanatorium or other building for the treatment or cure of pulmonary tuberculosis, or any infectious, contagious or communicable disease, within one-quarter of a mile from any building used or designed as a dwelling without the consent of the governing body of the municipality within which the building is to be located. Notice must be given of the application for such consent.

Although the bill comes from Ocean, it seems perfectly clear that it is aimed at the Verona project. It is possible that somebody in Ocean County designs to establish such a hospital, but Ocean County is large and thinly populated, and a hospital site can easily be found a quarter of a mile away from all dwellings. The prohibition is hardly needed in Ocean, anyhow. If not, what interest has an Ocean County man in hospital affairs in Essex County? And if his bill should pass, what possible provision could be made in Essex county for the care and treatment of consumptives? They could not be allowed in the city hospitals and it would

In Ocean County, introduction of the Taylor Bill sought to make it unlawful to construct or maintain any hospital or sanatorium for the treatment or cure of pulmonary tuberculosis within one-quarter mile from any building used or designed as a dwelling without the consent of the municipality within which the structure was to be located.

Although the bill did not originate locally, it was clearly aimed at the Verona project. At the time, Ocean County was thinly populated, and hospital sites could easily be found. Passage of the bill would ensure Essex County could not care for people stricken with tuberculosis, as the afflicted would not be allowed in city hospitals and it would be nearly impossible to find a location not within one-quarter mile of some dwelling. (Courtesy of Newark Public Library.)

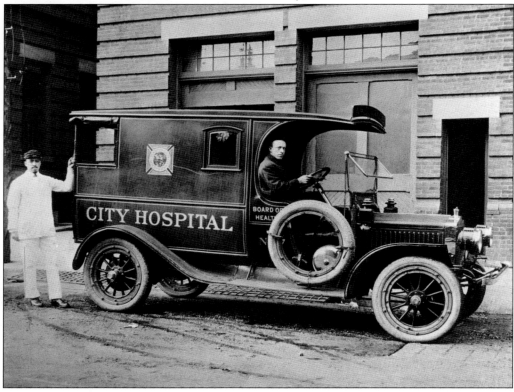

In November 1907, as protesters laid plans for one last effort, preparations for occupying the building moved forward, and Dr. Edward I. Gluckman (pictured) was chosen as superintendent. News leaked out that the citizens of Verona would seek an injunction to prevent the opening. Anticipating such a move, Dr. Gluckman moved several patients into the building at midnight, under the cover of darkness. Thus, the Newark City Home for Consumptives came into being. (Courtesy of Newark Public Library.)

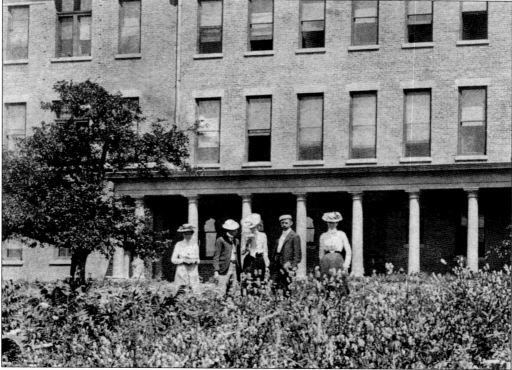

Those first few hardy pioneers could not stay long, however, as the building had deteriorated during its vacancy and needed extensive repairs. Walls were down or severely cracked, and floors were in bad shape, with some requiring replacement. A new kitchen range and laundry dryer were necessary, as was a hot water boiler. The interior was completely repainted, and porches extending across the front and side of the building were constructed. (Courtesy of Wilbur F. Jehl, MD.)

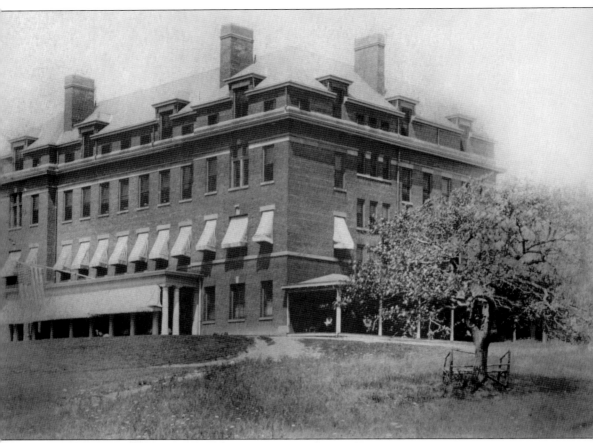

On January 21, 1908, the Newark Tuberculosis Sanatorium at Verona was reopened for patients. The building was 100 feet long and 60 feet wide, with three main entrances. It had two large stairways at either end, which led to the upper floors. The first floor contained the administration offices, kitchen, laundry room, engine room, and storeroom. The second floor held apartments for the doctors and the matrons, two large sitting rooms (one for men and one for women), and the dining room for nurses and patients. The third floor was for women and had three large wards, each with eight beds, and seven small rooms. Eight private rooms were available at a cost of $5 a week. There were also quarters for the help and nurses and two large bathrooms. The fourth floor was for men and had five wards (one large ward having 28 beds, two with 5 beds, and two with 4 beds) and two bathrooms. For entertainment, there was shuffleboard and a phonograph. Games were allowed, provided they would not strain the patients. (Courtesy of Robert L. Williams.)

Two

CHRYSALIS

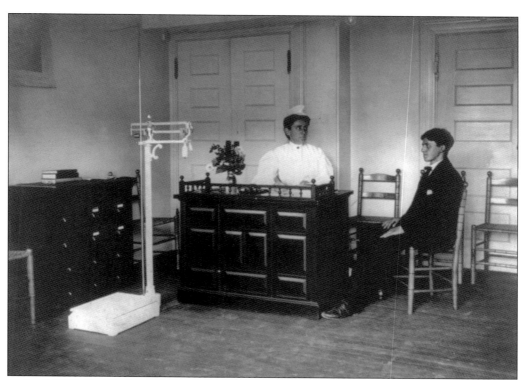

In April 1908, Dr. Gluckman submitted his report for the first quarter of the sanatorium's existence. Of the original $15,000 appropriated to the facility, there remained only $1.89. Although the hospital opened for the reception of incipient cases, the majority of the patients it received were in a moderately or far-advanced stage. With a capacity of approximately 80 beds, the facility invariably had a waiting list of 25 to 30 seeking admission. (Courtesy of Library of Congress.)

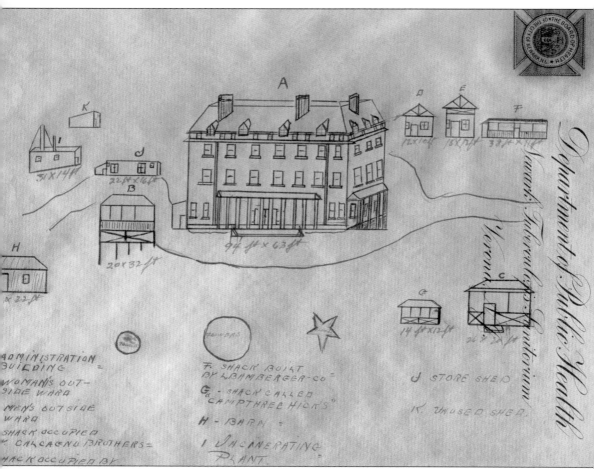

Demands on the hospital were already so great that funds were requested for the erection of several open-air structures, such as two pavilions, or "shacks," that would each hold an additional eight beds. For these purposes, the institution was allocated $3,000. This Newark Board of Health certificate shows the locations of numerous outbuildings and sheds that were constructed on the grounds, including a barn and an incinerating plant. (Courtesy of Wilbur F. Jehl, MD.)

Because treatment required spending as much time as possible outdoors, fires were sometimes lit so patients could gather in the afternoons of the colder months. Although it may be difficult to see, this photograph shows the remains of a bonfire with the main sanatorium building in the background. What is interesting about this image is that, on the right, one can see the lower portion of the shack referred to as "Camp Three Hicks," and just barely visible to the left is the roof of the women's pavilion. This is one of the rare photographs to show these temporary structures. (Courtesy of Wilbur F. Jehl, MD.)

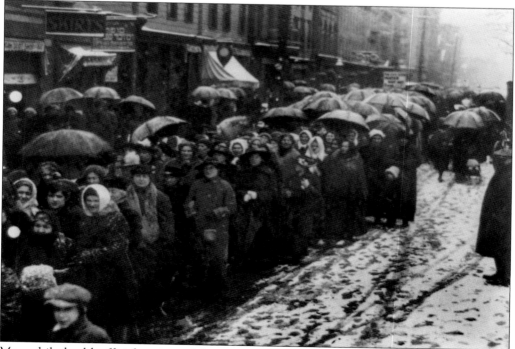

Meanwhile, health officials estimated there were anywhere from 3,000 to 5,000 cases of pulmonary tuberculosis amongst the citizens of Newark. Exact figures were impossible to determine at the time because the illness had only recently been put on the contagious disease list and become notifiable. It was clear, however, that the board of health's system was not working and the sanatorium, in its current state, was inadequate. (Courtesy of Library of Congress.)

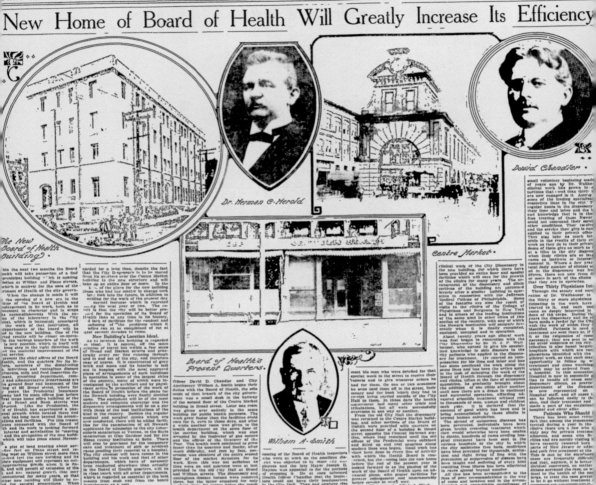

Over the next decade, the City of Newark began to wage a broader, far more intensive and effective campaign against the "white plague." The establishment of the Bureau of Tuberculosis and the reorganization of the board of health into both preventative and curative divisions, as well as the founding of the Anti-Tuberculosis Association, allowed the city to adopt more programs—such as the Newark Day Camp for Tuberculosis Cases, which began in 1908, and the Open Air School for Tuberculous Children. With the opening of the new Board of Health Building on November 1, 1913, the city dispensary now had more adequate provisions to increase its role in the antituberculosis effort. There were clinics held daily (except Saturday and Sunday) to diagnose active cases, and the Visiting Nurse Association supervised patients in their homes and educated families on prevention. Meanwhile, the sanatorium at Verona continued to run at its limits constantly, at full capacity and unable to keep up with demand.

DAILY HEALTH GUIDE
FOR
BOYS AND GIRLS

UP SMILING
No loitering
in dressing or
chores

A GOOD WASH
Before breakfast.
Brush your teeth.

MORNING
Brush teeth—Toilet

BREAKFAST
Fruit, cereals and plenty of milk,
eggs, bread and butter
No coffee nor tea at any meals
Eat slowly, walk to school. (Don't run.)

SCHOOL
GOING and COMING
Take ten deep breaths slowly,
shoulders straight and head up.
Don't sneeze near another person.
Use your handkerchief. Don't spit.

NOON
Wash your hands and face; use soap.
Glass of water before eating

DINNER
Besides meat and potatoes, or
rice, eat plenty of vegetables and
only plain puddings or fruits.
Chew each mouthful thoroughly.

AFTERNOON
Walk slowly after eating. Keep cheerful.
Play out of doors after school.

EVENING
Wash Face and Hands. Glass of water

SUPPER
Plenty of milk and fruits and fish or
eggs instead of meat.
Fried foods are hard to digest.

WINDOWS OPEN
Top and bottom
SLEEP OUT OF DOORS WHEN YOU CAN.

RECESS
Play hard.
Put nothing dirty
in your mouth.

FRESH AIR
Study hard.
Sit up straight
at your desk.

GLASS OF WATER
Brush Teeth.
A hot bath
twice a week

EARLY TO BED
12 hours sleep for
young children,
ten for all others

Distributed by the Newark Anti-Tuberculosis Association, 45 Clinton Street, Newark, N. J.

The Sinews of War vs. Tuberculosis.

Sold 3,517,760 Sold 5,125,224 Sold ?

Antituberculosis associations, or leagues, were private agencies designed to supplement public programs for the control of tuberculosis in their respective communities. They were official agents for the sale of Red Cross Christmas Seals in their district and as a rule received the net proceeds for their own use. Founded in 1909, the Newark Anti-Tuberculosis Association employed nurses who visited patients being admitted to or discharged from the sanatorium and followed up on all deaths. They maintained the dispensary clinic, conducted fresh-air farms each summer for tuberculous children, and were responsible for the founding of the first open-air classes in the state. Enforcers of the antispitting laws, their role was to educate the public through intensive campaigns by means of exhibits, lectures, and literature, like the above pamphlet, which was distributed throughout Newark schools to be hung in classrooms.

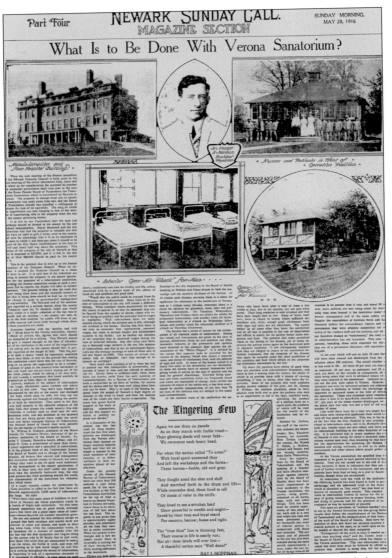

In 1912, laws were passed that made it the duty of New Jersey counties to provide hospital facilities for tuberculous patients, but a loophole in the law did not require each county to erect and maintain its own hospital, as they could opt to board them in other institutions. Between 1913 and 1916, Essex County had an average of 1,023 annual deaths from tuberculosis and only 326 beds available. To attain the standard of the day, which was "one bed for every death," 697 more beds were required. In 1917, the Newark Board of Health suggested that the county finally fulfill its obligation by taking over the Verona institution and enlarging it to meet the ever-increasing need. Legislation was introduced, but financial disputes halted the agreement; the county believed the facility should be deeded over without restitution, while city authorities felt they should be compensated for the valuable land and buildings. The city prevailed, and on April 1, the board of freeholders agreed to purchase the sanatorium and 32 acres of land for $32,000. More political wrangling delayed the acquisition, however, and by August, the hospital was out of money and near closure. At the last minute, a resolution was passed providing for the transfer, and a board of managers was appointed, establishing Essex County's Mountain Sanatorium.

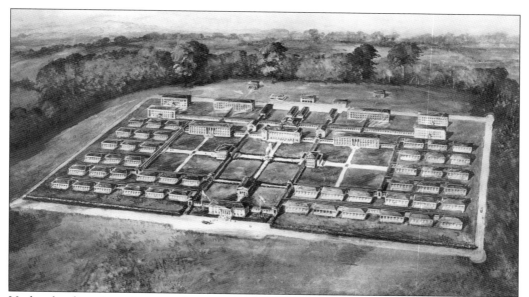

Under the direction of state and national tuberculosis associations, architects, and sanatoria experts, proposals were submitted for enlargement of the Verona institution. In this conceptual design, the larger buildings in the center and toward the rear would be utilized for administration, employee housing, hospital use, and communal purposes, while the number of outer, smaller open-air pavilions would be used for ambulant patients. Although similar in principle, the plot plan of the completed complex would, in reality, be much different. (Courtesy of Newark Public Library.)

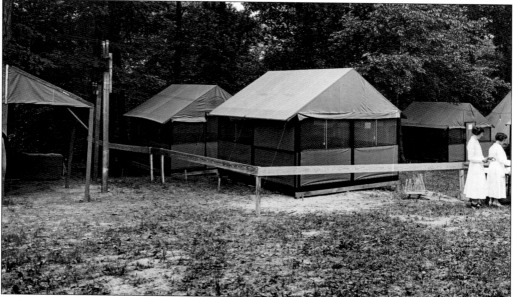

Before the county could break any ground for the enlargement of the facility, the Spanish influenza pandemic of 1918 necessitated the erection of temporary shacks and tents on the sanatorium grounds. Diagnostic aids for tuberculosis were now readily available, and as the flu subsided, the temporary buildings were used to care for the ever-accumulating number of discovered cases. (Courtesy of Library of Congress.)

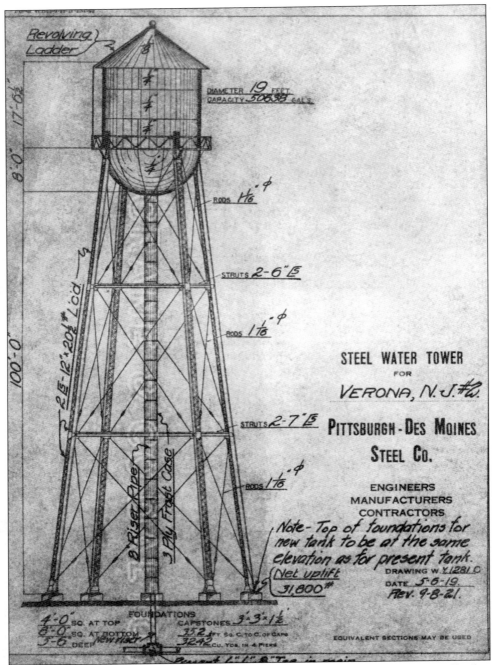

Revolving Ladder

8'

DIAMETER 19 FEET
CAPACITY 50638 GAL'S

17'-6½"

8'-0"

RODS 1⅝" φ

STRUTS 2-6" E̅

100'-0"

2L5-12"×20.4" L/Ld

RODS 1⅝" φ

STEEL WATER TOWER

FOR

VERONA, N. J. #2

STRUTS 2-7" E̅ PITTSBURGH-DES MOINES
STEEL CO.

8" Riser Pipe

3 Ply Frost Case

RODS 1⅝" φ

ENGINEERS
MANUFACTURERS
CONTRACTORS

Note- Top of foundations for
new tank to be at the same
elevation as for present tank.
(Net uplift
31,800#

DRAWING W. Y. 1281 0
DATE 5-6-19.
Rev. 9-8-21.

FOUNDATIONS
4'-0" SQ. AT TOP CAPSTONES 3'×3'×1½"
8'-0" SQ. AT BOTTOM 15.2 FT. SQ. C. TO C. OF CAPS
5'-6" DEEP New Hgt. 32.42 CU. YDS. IN 4 PIERS

EQUIVALENT SECTIONS MAY BE USED

To make expansion feasible, some fundamental issues needed to be addressed, especially that of water supply. The sanatorium had been connected to the Newark City Home's system, which was considered inadequate for the original buildings, let alone any future structures. A 135-foot-tall water tower with a capacity of 50,638 gallons was erected on the northern end of the property. As the complex grew, the demand for water increased, and two years later, an identical sister tower was added.

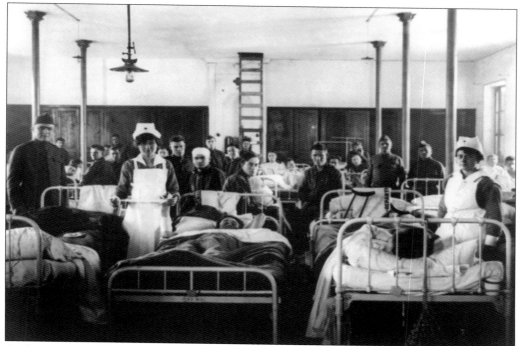

As the sanatorium began treating patients sent from all portions of Essex County's 21 communities, the end of World War I in the fall of 1918 also saw the influx of returning soldiers who were wounded in battle. The institution would become a haven for veterans who had suffered lung injuries during wartime. (Courtesy of Library of Congress.)

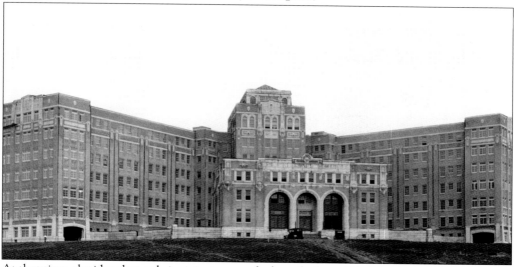

At that time, the idea that only incipient cases of tuberculosis could be cured was widely accepted. The majority of sanatoriums only accepted incipient cases for treatment, and this ideology determined the policy that the county adopted when it took over the care of those afflicted with tuberculosis. Chronic and terminal cases would be housed at the County Isolation Hospital (pictured in 1932) in Belleville, and the Verona sanatorium would be enlarged to provide for the "curable," or incipient, cases. (Courtesy of Newark Public Library.)

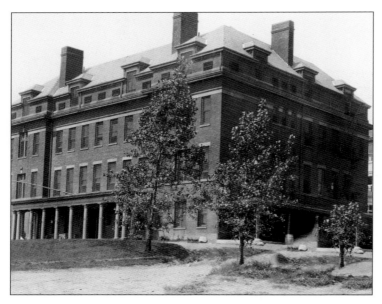

In conformity with this policy, the first stage of expansion began in late 1917 when ground was broken on 11 new buildings, which were completed and opened to patients in 1922. In the photograph at left, note the presence of a structure just behind the original building. Construction of the new hospital addition was nearing completion at this time. (Courtesy of Newark Public Library.)

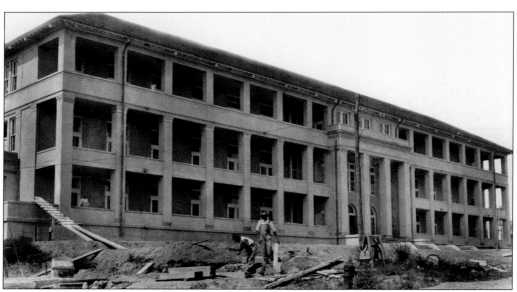

When finished, the new Hospital Building could accommodate 132 desperately needed beds, more than doubling the sanatorium's capacity. It was connected to the rear of the original unit by way of an elevated, multilevel corridor, which is barely visible on the far left of this photograph. This building would later be referred to as the Infirmary after completion of a new, larger hospital wing in 1930. (Courtesy of Newark Public Library.)

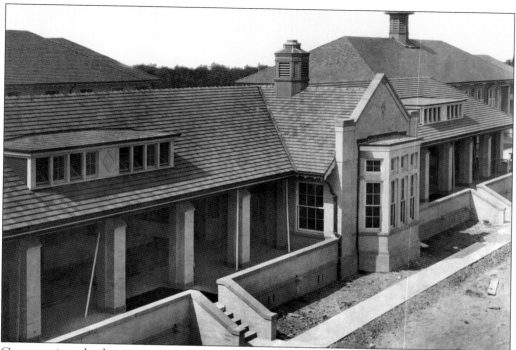

Construction also began on open-air pavilions, referred to as "shacks," for ambulant patients. The sanatorium would have four of these identical pavilions, designated A, B, C, and D. Each held 24 beds, increasing the sanatorium's total by 96. This photograph shows the nearly complete Pavilion A. (Courtesy of Newark Public Library.)

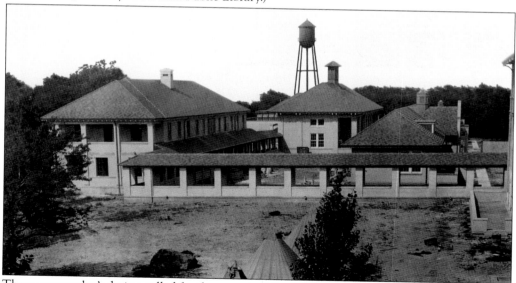

The new complex's design called for the outer buildings to be connected by covered corridors or walkways. This image shows the construction of the nurses' residence on the left, the kitchen and dining hall in the center, and Pavilion A on the right. Note the small foundation (far right) at the base of the Hospital Building. This would be used for a small open-air porch, or sleeping shack. (Courtesy of Newark Public Library.)

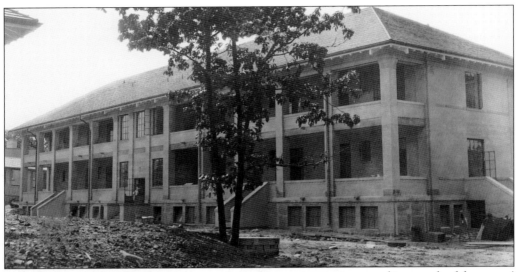

A smaller hospital building—or Annex, as it was known—was constructed just north of the nurses' residence and dining hall. This structure would have many uses during its lifetime, including those of a supplemental infirmary and housing for patients who could not pay. This photograph was taken on August 24, 1921. (Courtesy of Newark Public Library.)

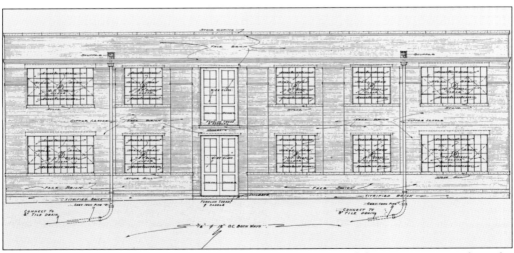

Three industrial buildings were erected at the southeast corner of the property, apart from the main complex. They were used as a laundry building, a boiler house (pictured), and a maintenance garage. Unlike the other sanatorium structures constructed during this period, these buildings were of a plain, utilitarian style, made of red brick, not white. Both the laundry building and boiler house would require additions before the end of the 1920s. (Courtesy of Essex County Department of Public Works.)

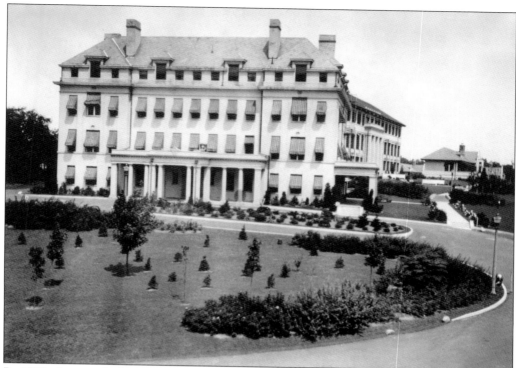

By 1925, the initial phase of the facility's enlargement had been completed, and the complex had grown to 12 buildings. The roads were now paved, and the grounds were improved with new lawns and plantings. The sanatorium's design, initially inspired by the spa movement, allowed it to maintain the aura of a health resort despite having become a large-scale hospital. Note that the original City Home cottage had been whitewashed to match the new structures, giving the institution a more sterile and sanitary appearance. (Courtesy of Newark Public Library.)

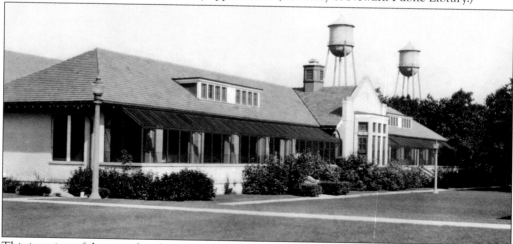

This is a view of the completed Pavilion C. These open-air wards were used by patients for sleeping outside year-round and were the last course in treatment before one returned home. Note that, by the mid-1920s, the second water tower had been installed on the property. (Courtesy of Newark Public Library.)

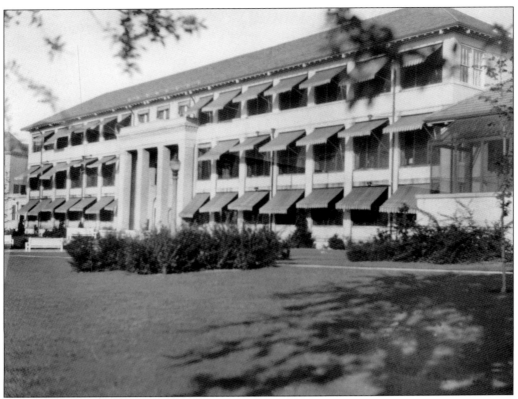

Because fresh air and sunlight were considered so vital to treatment, proper ventilation was an integral part of sanatorium design. Many physicians also believed that "re-breathed" indoor air containing tubercle bacilli made recovering patients susceptible to relapse. As a result, the new Hospital Building's large windows were kept open regardless of temperature. Awnings were necessary in the summer months to keep the institution cool. (Courtesy of Newark Public Library.)

ESSEX MOUNTAIN SANATORIUM

DIAGNOSIS

INCIPIENT

Slight or no constitutional symptoms (including gastric or intestinal disturbance, or rapid loss of weight); slight or no elevation of temperature or acceleration of pulse at any time during the twenty-four hours;
Expectoration usually small in amount or absent. Tubercle bacilli may be present or absent.
Slight infiltration limited to the apex of one or both lungs, or a small part of one lobe.
No tuberculous complications.

MODERATELY ADVANCED

No marked impairment of function, local or constitutional.
Marked infiltration more extensive than under incipient, with little or no evidence of cavity formation.
No serious tuberculous complications.

FAR ADVANCED

Marked impairment of function, local and constitutional.
Extensive localized infiltration or consolidation in one or more lobes.
Or disseminated areas of cavity formation.
Or serious tuberculous complications.

Upon entrance and examination, patients were classified, according to the extent of their lesions, into one of three stages— incipient, moderately advanced, or far advanced—and were either transferred to the isolation hospital, which was referred to as "SoHo," or placed in the appropriate wards. By 1925, the sanatorium was nearing its 400th death since county acquisition; at that time, nearly 25 percent of those who entered the institution died.

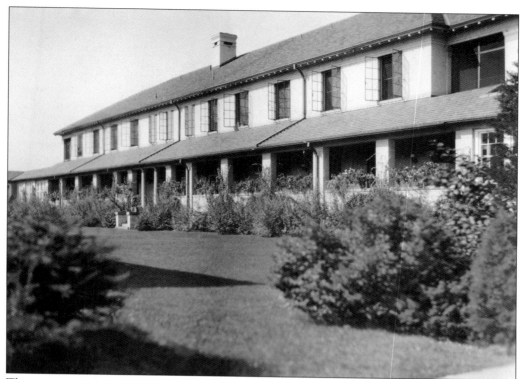

The nurses' residence provided amenities for the ever-increasing number of staff required by the growing facility. The first floor featured a kitchen and laundry room for the nurses' personal use and two large sitting rooms equipped with fireplaces. Private rooms on the second level consisted of a small closet and sink and were furnished with a bed, nightstand, and dresser. (Courtesy of Newark Public Library.)

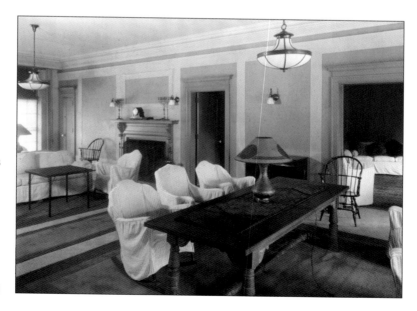

The sitting rooms in the nurses' residence were where nurses would often gather to socialize and have tea, read, or play cards. This area was used to temporarily board the sanatorium's male medical personnel until sufficient housing could be constructed for them. (Courtesy of Wilbur F. Jehl, MD.)

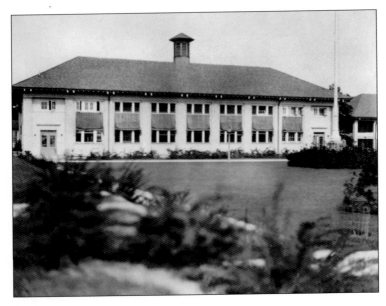

The dining hall served ambulant, or "shack," patients as well as nonresident employees. Meals were permitted outside in nice weather, and the large lawn featured a central flagpole and was used for outdoor gatherings and events. Although the hall's exterior appearance would not change, a growing sanatorium necessitated the upgrading and remodeling of the interior several times. (Courtesy of Newark Public Library.)

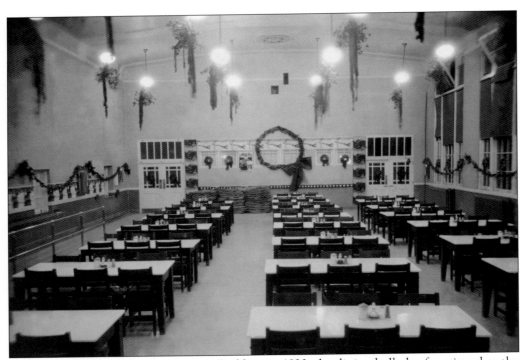

Until the addition of the Community Building in 1930, the dining hall also functioned as the institution's auditorium for meetings, assemblies, and major announcements. This photograph, taken in the month of December, shows the hall adorned with swags, wreaths, and garland for the holiday season. These festive decorations were all made by patients. (Courtesy of Newark Public Library.)

During the 1920s, the ratification of the 19th Amendment to the Constitution had resulted in the emergence of women in both local and national politics. Elizabeth A. Harris (pictured) of Glen Ridge, New Jersey, was selected to serve on Essex County's Board of Chosen Freeholders. She immediately sought legislation to abolish the sanatorium's board of managers and give the freeholders direct control of the institution. Although the bill was bitterly opposed, the county was successful in securing its passage. (Courtesy of the Women's Club of Glen Ridge.)

After being made chairman of the Verona Sanatorium Committee, Harris began acquiring information enabling her to deal intelligently with any issues that might arise regarding the institution. When she asked the National Tuberculosis Association to conduct a survey of the local tuberculosis problem, many of their suggestions conflicted with the county's original plan regarding sanatorium facilities and future development. (Courtesy of Essex County Department of Public Works.)

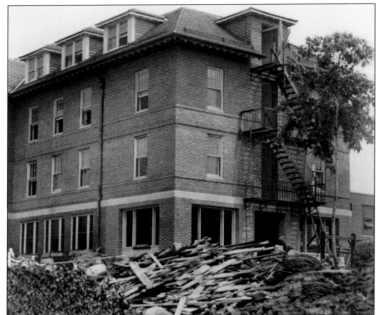

The National Tuberculosis Association immediately made a call for more beds. To meet the demand for increased capacity, a plan to secure at least 37 employee beds from the Male Employee Home (which was nearing completion just west of the laundry building and boiler house) for patient use moved forward. (Courtesy of Newark Public Library.)

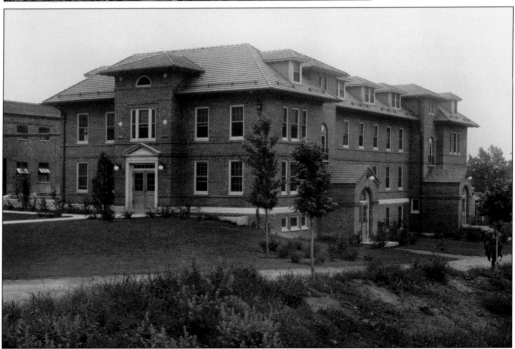

The Male Employee Home, which opened in early 1926, was designed as a dormitory and featured single- and double-occupancy units, communal bathroom facilities, and a large living room and open porch in the rear. Hot water was supplied to the home through a 40-foot-long pipe that was suspended 15 feet in the air from the laundry building. Although originally intended to house employees, many of its 81 beds were commandeered for patient use during times of overcrowding. (Courtesy of The New Jersey Historical Society.)

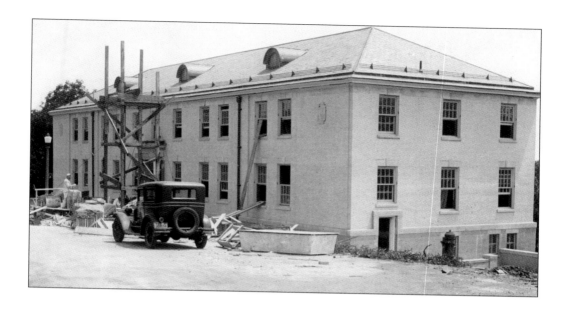

Other recommendations from the survey included a still larger institution and the centralization of the county's tuberculosis program into one facility, meaning the sanatorium would now care for patients in all stages of the disease. To accommodate the growing number of nurses and medical staff needed to care for those bed cases, plans immediately got under way for construction of the Female Employee Home (above) and the Medical Staff Building (below). (Above, courtesy of Newark Public Library; below, courtesy of Wilbur F. Jehl, MD.)

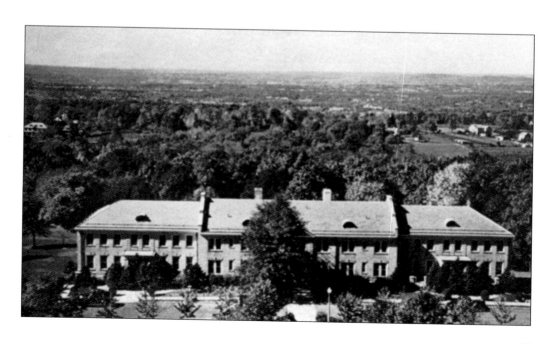

Meanwhile, the office of superintendent of the sanatorium had become vacant, and a new head for the institution was urgently needed. Dr. Byron M. Harman (pictured), a graduate of the University of Pennsylvania Medical College and himself a victim of tuberculosis, was chosen. In 1929, he was found guilty on four charges of misconduct and removed from the position. Three of the charges originated from improprieties with two former telephone operators at the sanatorium. The fourth dealt with the unlawful termination of Eloise Travers, a night supervisor of nurses. Two days after testifying at the trial, Travers either jumped or was pushed in front of a subway train in New York City and was killed. In August 1932, the New Jersey State Supreme Court ruled that Dr. Harman's dismissal was unjustified due to lack of evidence, and he was reinstated. (Courtesy of Newark Public Library.)

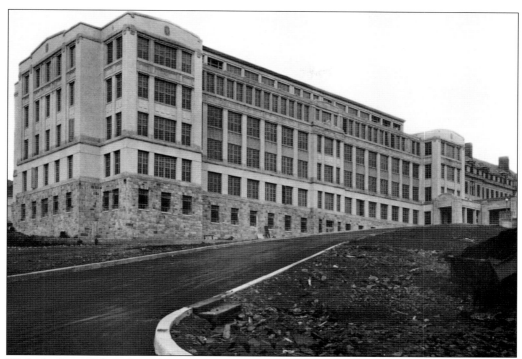

With the last of the tuberculous patients brought to the sanatorium from the County Isolation Hospital, centralization of the county's program was achieved. Requests were still coming in for at least 100 more beds however, and Mrs. Harris pointed out that any additional beds would also require an expansion in other services, such as larger kitchen, laundry, and power buildings. The county also had no facilities for tuberculous children, as the board of chosen freeholders had been providing for their care in the preventorium at Farmingdale. Authorities were called in to prepare designs for a new addition to address these needs, but before the plans could be put into effect, Elizabeth Harris was relieved of her duties as chairman. When the new hospital unit (pictured) was opened in late 1930, many of the features she had campaigned for, such as the children's wing, were missing. (Above, courtesy of Newark Public Library; below, courtesy of Robert L. Williams.)

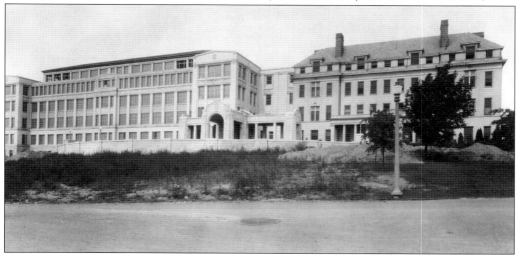

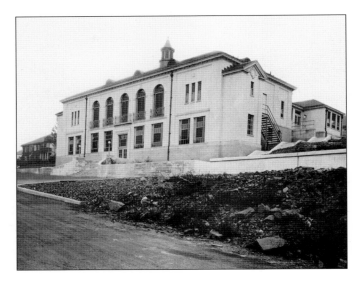

Chairman Harris was successful, however, in ensuring that one of her last and most cherished projects—the construction of the Community Building—came to fruition. Designed to foster a patient's spiritual, emotional, and mental well-being, it housed the chapel for prayer and religious services, the auditorium for entertainment, the sanatorium school for educational needs, and the occupational therapy department and its associated store. (Courtesy of Newark Public Library.)

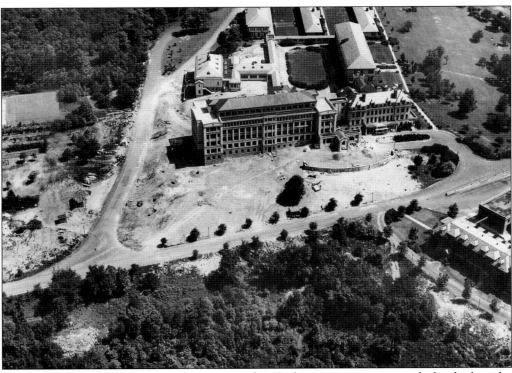

This aerial photograph, taken in the summer of 1930, shows construction nearly finished on the hospital and community units as well as their connecting corridors. Despite the ever-present need for increased capacity, these new buildings would be the last major structures erected on the site. Although recommendations would be submitted for future additions—such as for an almshouse for elderly and chronically ill, indigent patients—they would never be implemented. (Courtesy of Newark Public Library.)

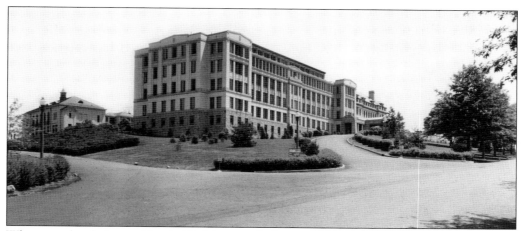

When completed, the new Hospital Building was the largest of the complex and had accommodations for an additional 136 beds. With a total bed capacity of 422, the mountaintop institution could now offer plenty of sunshine, bed rest, fresh air, and good food to over 700 patients annually, in all stages of the disease. (Courtesy of Verona Public Library.)

Prior to the opening of the Community Building, and the sanatorium's proper occupational therapy department, a patient's diversional activities would include assisting the X-ray and clerical departments, working in the supply rooms making gauze dressings, or performing tasks such as winding the institution's clocks. Other occupational duties consisted of "ward work," which involved delivering mail, puzzles, and newspapers to the bedside, and a library service to the wards known as "Books to Beds." Barbers and manicurists were also permitted to practice their trade on other consenting patients. (Courtesy of Newark Public Library.)

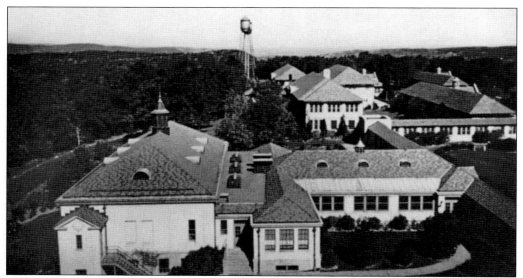

This is a view looking north from the Hospital Building with the new Community Building in the foreground. The sanatorium's construction followed design conventions of the day, which called for several individual buildings, normally two stories or less, that segregated men and women and housed specific patient types. The critically ill would be housed in the hospital, with ambulatory patients farthest away in the shacks. Patients could then be brought together in communal buildings such as auditoriums, chapels, or dining halls. (Courtesy of Wilbur F. Jehl, MD.)

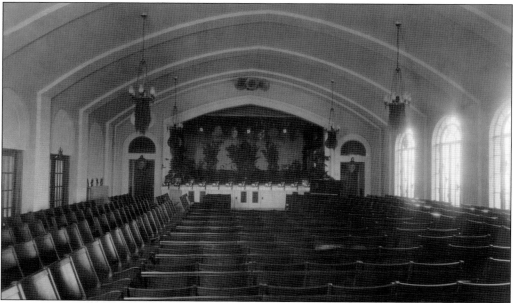

The new auditorium allowed for numerous diversional activities that had not been possible in the institution's past. Movies were shown weekly, and social events were held with dancing, refreshments, and prizes. Ambulatory patients also enjoyed volunteer performances by orchestras, bands, choirs, drama clubs, and music therapy classes from the nearby asylum at Overbrook. Those too ill to attend could listen from their beds, as programs would be broadcast throughout the sanatorium by way of a radio hookup. (Courtesy of Robert L. Williams.)

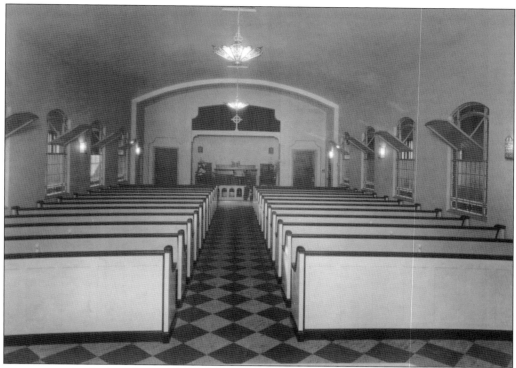

The sanatorium's chapel was nondenominational, with daily and Sabbath services performed by visiting reverends and rabbis. Flowers for altar arrangements were grown by inmates of the penitentiary in North Caldwell and were supplied to the institution courtesy of the warden. Patients assisted the chaplains with altar dressings, brass polishing, and keeping the sacristy in order for the various religions. If physically unable to attend services, patients could receive Communion at their bedside on the wards. (Courtesy of Essex County Department of Public Works.)

The sanatorium school was founded to assist patients whose educations had been interrupted by hospitalization. Because of varied requirements, a school curriculum ranging from primary studies up through high school standards was developed in cooperation with public schools in the vicinity, and a full-time teacher was hired by the local board of education. Students were able to complete their studies and advance or graduate with members of their regular classes.

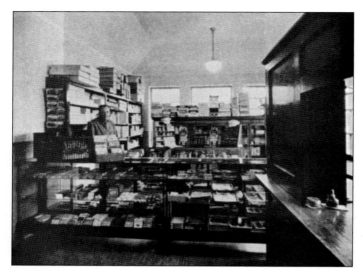

The sanatorium store was established in the Community Building in 1931 to supply patients with small personal items and novelties. Yo-yos, playing cards, and puzzles were top sellers, as were pencils and paper for writing letters and sketching. Prints and postcards of the sanatorium were available for purchase and were popular with visitors. Patient storekeepers, in addition to their work in the shop, would also assist with daily bedside deliveries.

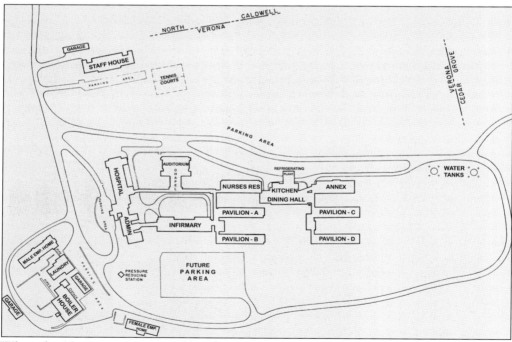

When the 12-year expansion and building campaign concluded in late 1930, the sanatorium complex consisted of 20 buildings on over 200 acres. Steam, water, and electricity were supplied to the new structures by a network of underground tunnels. The original unit of the facility, the City Home cottage, now served as the Administration Building. With the exception of the large parking area added in the 1940s, the plot plan would remain unchanged for 63 years, until 1993. (Courtesy of Essex County Department of Public Works.)

Three

THE CROWN JEWEL

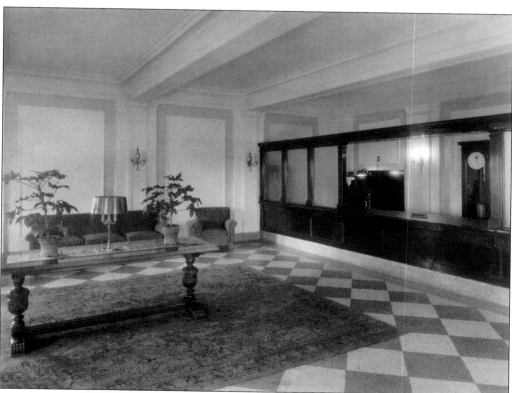

The hospital reception area, with its ornate pilasters and cornices, was designed to impress. The desk, or partition, appears to be made of wood but was actually metal with glass panels. The sanatorium's main telephone switchboard can be seen behind the counter. Also note the terrazzo floors; brass dividers would be set into the cement to form these patterns. (Courtesy of Wilbur F. Jehl, MD.)

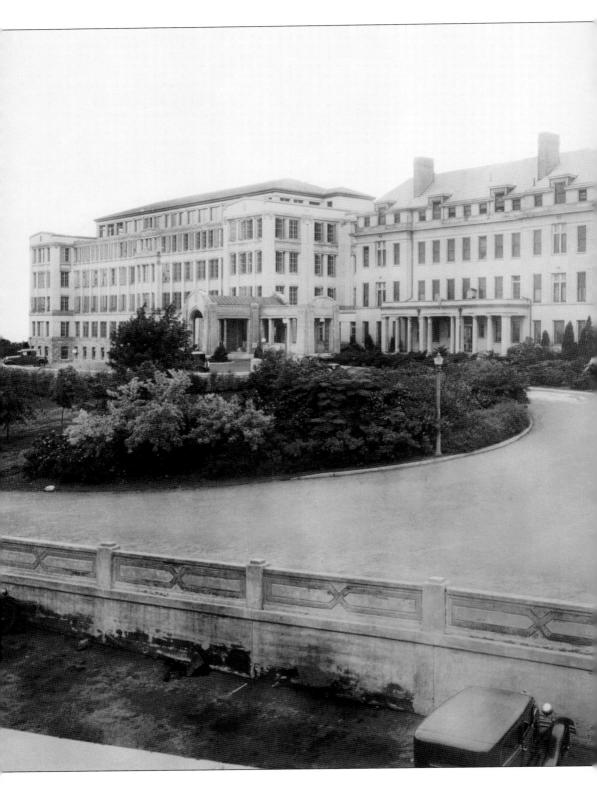

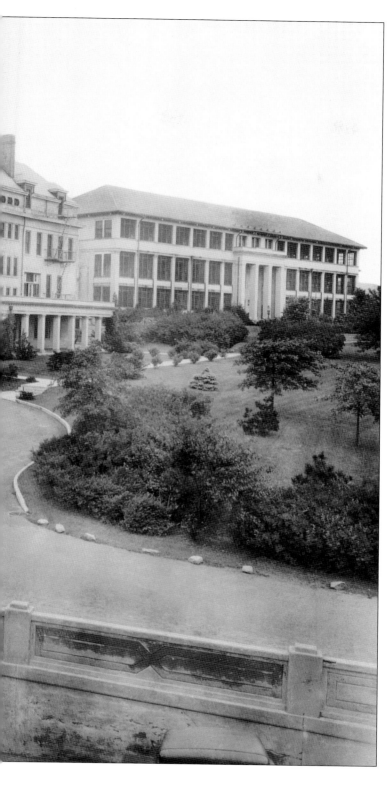

With a first-floor altitude of 784 feet above sea level, the Essex Mountain Sanatorium was equipped with all the newest technologies to perform the surgeries, procedures, and therapies of the day. With the exception of the reception area and the admitting and receiving wards on the first floor, the lower levels of the Hospital Building (left) were nearly identical, with operating rooms, doctors' and nurses' areas, serving kitchens, and bathrooms facing north, while across the hall, patient rooms were in the center, with large dayrooms and a solarium at each end, all with a southern exposure. The morgue was located in the basement, and the top floor was made up of covered porches, or "air baths," and rooms fitted with Vita Glass. At each end were large, flat, open roofs known as "heliotherapy decks," where patients would spend time out in the sunshine year-round. The lower floors of the Administration Building (center) held the superintendent's office, head nurse's office, social service department, conference rooms, and the institution's library. On the upper floors were the pharmacy, laboratories, and dental offices. The Infirmary (right) had patient rooms on the first floor and large, open wards occupying the upper floors. (Courtesy of Wilbur F. Jehl, MD.)

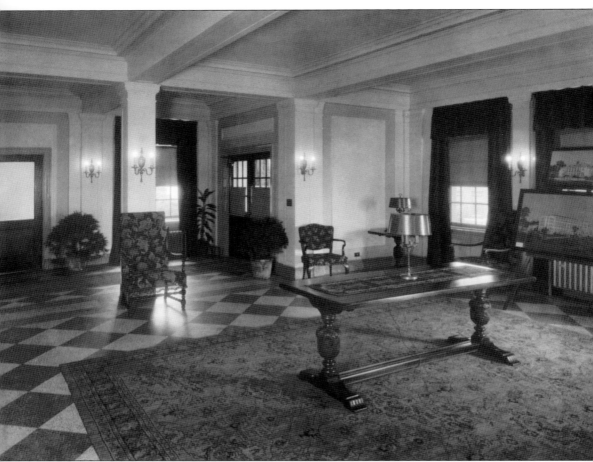

This is a view of the reception area facing the main entrance and vestibule, which was accessed through the porte cochere. The secretary's office was to the left, and just farther out of view were built-in telephone booths and a set of double doors that led to the admitting ward. Note the easel on right holding paintings of the two recently completed structures, the Hospital and Community Buildings. (Courtesy of Essex County Department of Public Works.)

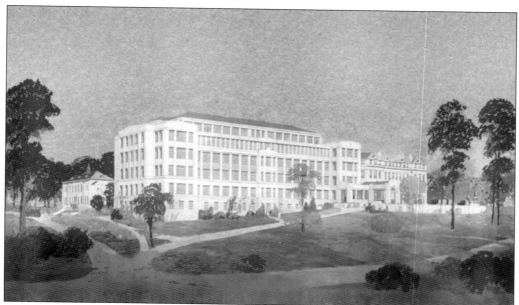

These artist renderings were commissioned by the architectural firm Sutton & Sutton, the designers of the new buildings. When the sanatorium closed, both the Hospital Building painting (above) and the Community Building painting (below) were moved to Overbrook's Administration Building. A third watercolor, which was presented to Edith Hyde Colby, the chairman of the Verona Sanatorium Committee, on her departure from the position, is mentioned in Supt. Byron Harman's annual report for 1940, but no photographs of this artwork exist, and its whereabouts are unknown. (Both, courtesy of Wilbur F. Jehl, MD.)

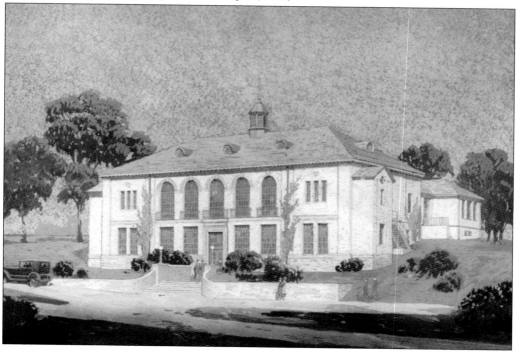

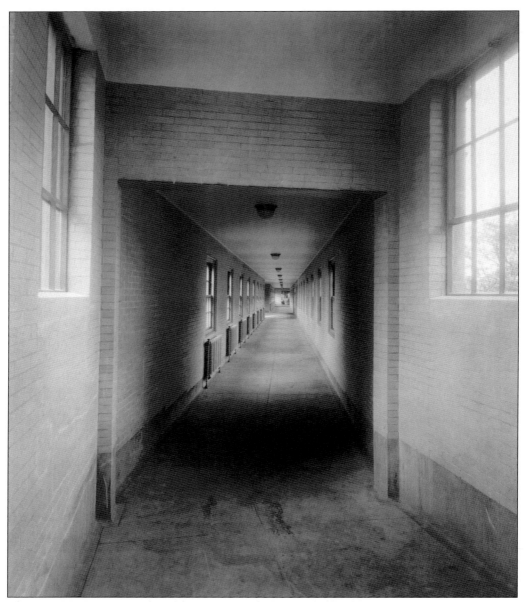

This is an interior view of the newly constructed service corridor that linked the new Community Building to the rest of the complex. This photograph is looking north from the western hospital bridge toward the nurses' residence and dining hall. The entrance to the chapel is about midway down, on the left. (Courtesy of Essex County Department of Public Works.)

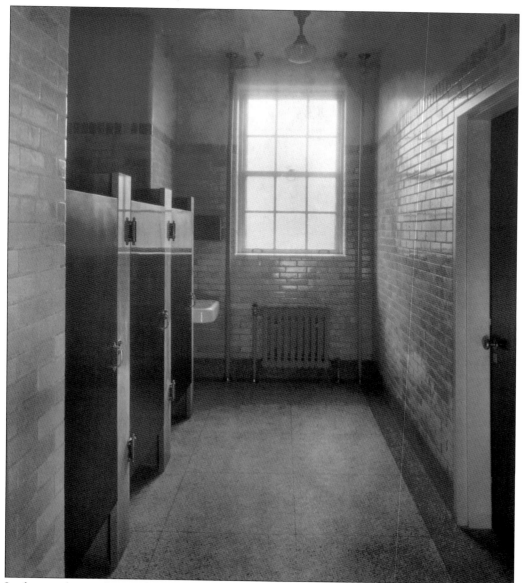

In the new hospital wing, lavatories for women patients had three stalls. Lavatories for men had only two, with a urinal in place of the third. Both male and female versions promoted good hygiene and featured materials that could be easily disinfected, such as glazed ceramic tile and porcelain splash-proof sinks. The door on right led to a small private room with a single bathtub and shower. (Courtesy of Essex County Department of Public Works.)

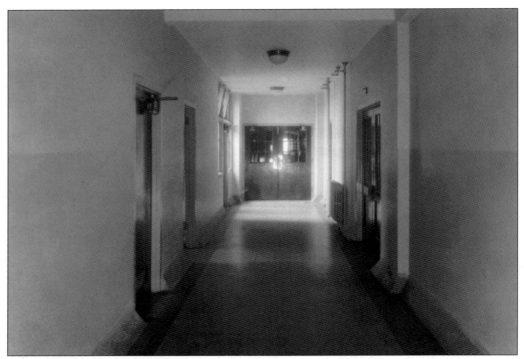

The sanatorium's long corridors were broken up by a series of doors that created smoke barriers and fire partitions. Known as kalamein doors, they were of a solid wood core covered with galvanized sheet metal with wired-glass windows. Also note the terrazzo floors and large base molding. This skirting was used to prevent marring of the walls by wheeled hospital beds, which were frequently moved throughout the institution, and to inhibit the accumulation of dust and dirt harboring contagious tubercle bacilli in corners. (Both, courtesy of Essex County Department of Public Works.)

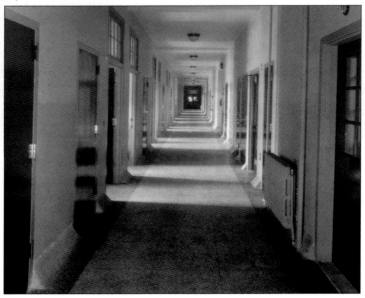

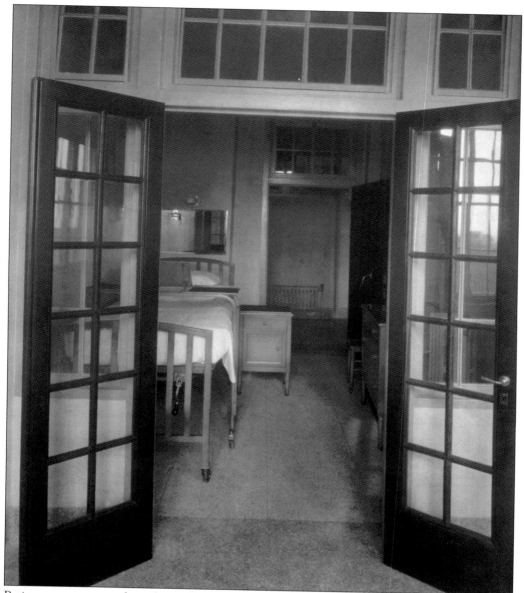

Patient rooms were relatively small—just under 90 square feet—and contained a single bed, sink, chair, nightstand, and dresser. Each row of seven individual rooms was linked by a shared, enclosed porch, which was over 60 feet long. Sanatorium design guidelines discouraged the use of doorsills, or thresholds, as beds needed to be rolled out on to the porches through a set of French doors. (Courtesy of Essex County Department of Public Works.)

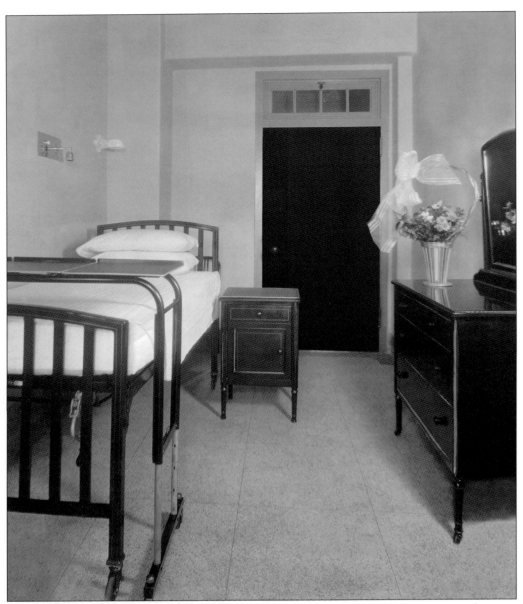

Private rooms along the western edge of the Hospital Building, which had no access to the open porches, contained the patients classified as moribund, or near death. These rooms kept the sickest individuals apart from the rest of the sanatorium community, and their location at the end of the building, in close proximity to the morgue below, allowed for a quick and concealed removal of the body. (Courtesy of Essex County Department of Public Works.)

With individual rooms being reserved for patients in the moderate to far-advanced stages of the disease, larger rooms (referred to as wards) held multiple beds and accommodated less-serious cases. This is a photograph of a typical three-bed ward. There were a total of 11 three-bed wards in the Hospital Building, two on the first floor and three each on floors two through four. (Courtesy of Essex County Department of Public Works.)

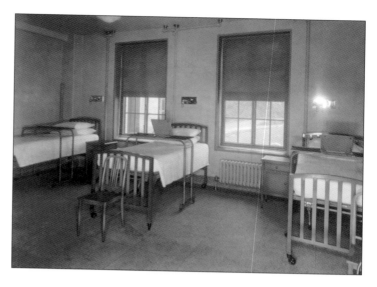

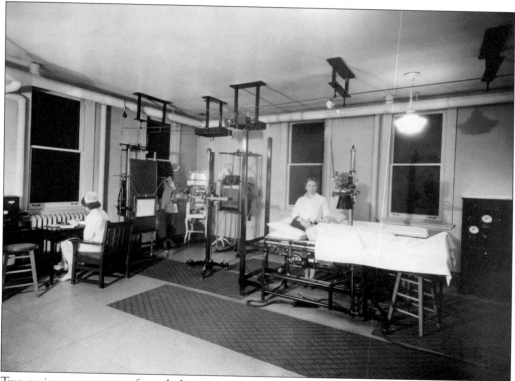

Two main components of a radiology room at the sanatorium were a fluoroscope (left) and an X-ray bucky table (right). A fluoroscope was used to give physicians a "live" X-ray image. Made while the patient was breathing, it could reveal lung problems that were not apparent in static X-rays. A bucky was a device found underneath the exam table that held a sheet of film and moved it during exposure. The motion kept lead strips from being seen on the X-ray, resulting in a clearer picture. (Courtesy of Wilbur F. Jehl, MD.)

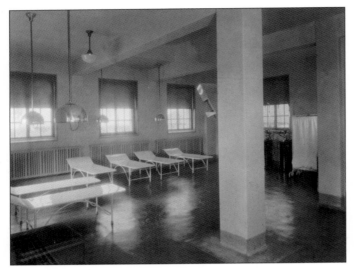

Because ultraviolet (UV) rays were known to kill tubercular bacilli, sunbaths became a part of healing regimens in sanatoriums. Heliotherapy departments often featured lamp rooms (pictured), which allowed for artificial UV therapy at night or in inclement weather. Despite being highly effective in treating tuberculosis of the glands, bones, skin, and eyes, results of heliotherapy in the treatment of the pulmonary form were not as encouraging. (Courtesy of Robert L. Williams.)

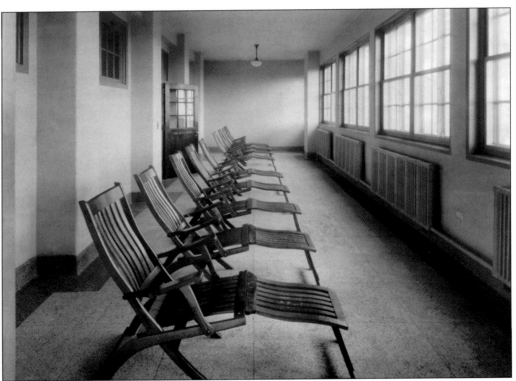

This photograph shows carefully placed "cure chairs" in one of the sanatorium's Vita Glass rooms. While ordinary window glass absorbs nearly all ultraviolet rays, the specially prepared Vita Glass was transparent to the UV spectrum, permitting exposure to the sun's UV rays indoors. Although groundbreaking in its day, Vita Glass was a financial and marketing failure that never quite caught on. Manufacturing winded down in the late 1930s and never resumed. (Courtesy of Essex County Department of Public Works.)

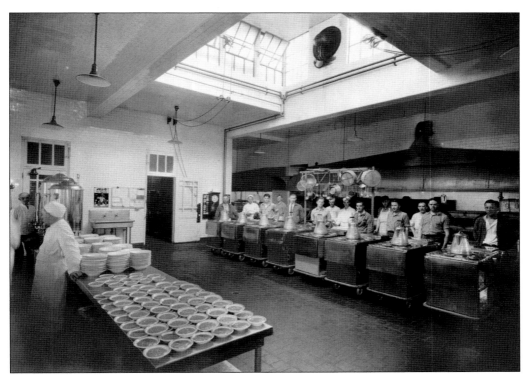

The main kitchen, originally constructed in the early 1920s when the sanatorium could accommodate only 220 consumptives, needed major renovations in order to meet demands of the expanded facility, which at the time of this photograph had nearly doubled in patient capacity to 422. Prepared meals would be served to the dining hall through windows located just out of view to the left. The individual carts were used to transport food to the individual serving kitchens located throughout the institution. (Courtesy of Newark Public Library.)

Each of the hospital's first four floors had its own serving kitchen, which was used as a staging area for meal delivery. Food was prepared and cooked in the main kitchen and then brought to these areas to be assembled into meals and delivered to the patients. A steam table and warming racks were utilized to keep food warm. (Courtesy of Newark Public Library.)

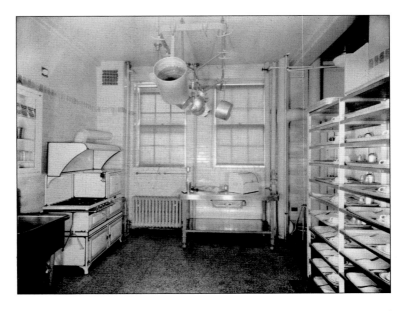

The sanatorium was also equipped with what were referred to as "diet kitchens" for special dietary needs. Similar to a serving kitchen, they were used to prepare meals for patients who were on restrictive diets as a result of hypertension, diabetes, or for those with food allergies. (Courtesy of Newark Public Library.)

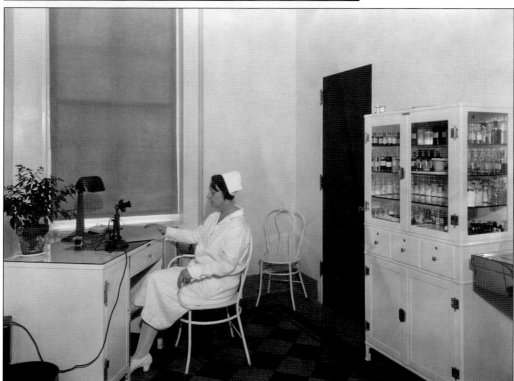

Nurses' stations were located on each floor of the Hospital Building and allowed for the execution of both clinical and administrative tasks. Many nurses were themselves survivors of tuberculosis. While only a small percentage contracted the disease while working, many were recruited by sanatoriums seeking to find positions for their ex-patients. Since TB's potent stigma often limited employment opportunities, even for those considered cured, nurse training represented the best option for many women. (Courtesy of Wilbur F. Jehl, MD.)

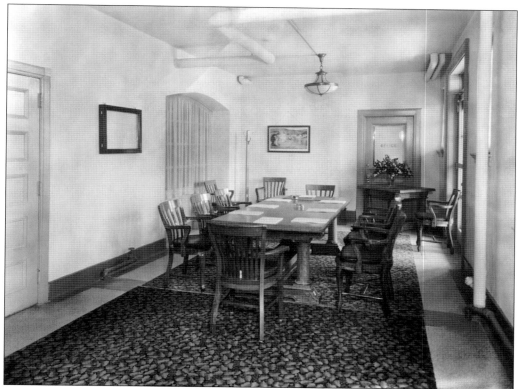

The board room, located on the first floor of the Administration Building, was used by the Verona Sanatorium Committee and the superintendent to deal with legal and political affairs concerning the institution. Before completion of the new Hospital Building, the lobby of the original sanatorium occupied this space, with the chair on the far right wall placed in front of what was then the main entrance door. (Courtesy of Wilbur F. Jehl, MD.)

The sanatorium's library provided patients access to a wide variety of books, periodicals, and daily newspapers. A large portion of the reading material was donated, with subscriptions to popular magazines such as *Life* and *National Geographic* being gifts of the county, while the Essex County Tuberculosis League supplied issues of the *Saturday Evening Post* and *Collier's*. *Reader's Digest* would send the library 15 copies of their magazine one month after regular publication.

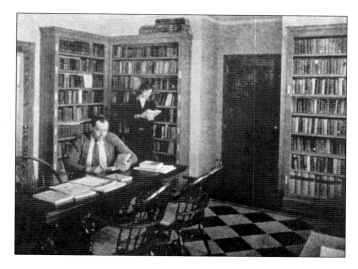

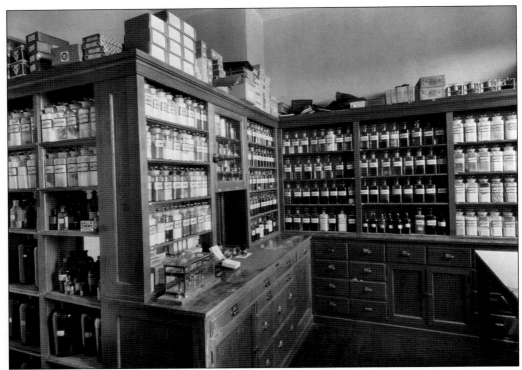

Pictured above is the original sanatorium pharmacy, which featured wooden cabinetry. Prior to the Harrison Act of 1914, opium, morphine, and cocaine were widely used in over-the-counter or patent medicines and could be dispensed legally by pharmacists. Through 1910, diacetylmorphine was marketed by Bayer under the trademarked name Heroin as a cough suppressant. Arsenic, in small quantities, was given to patients, and mixtures of turpentine oils were used as expectorants. Toxic bromide compounds were frequently used as sedatives, and the highly volatile potassium chlorate, which was used as an antiseptic, could easily explode while being prepared. Changes in pharmaceutical regulations and evolving fire codes required the renovation of the old pharmacy, and the photograph below shows the necessary upgrades and improvements, such as metal cabinets and a sprinkler system. (Both, courtesy of Wilbur F. Jehl, MD.)

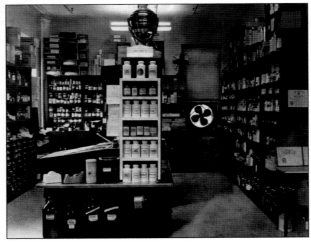

The long duration of tuberculosis treatment necessitated the establishment of a full-time dental department at the sanatorium. In addition to providing routine dental care for chronic patients, sanatorium dentists also treated the nearly 85 percent of those that suffered from some form of dental condition upon admittance. In many instances, dental problems were so extensive that, unless remedied, they jeopardized a patient's chance at recovery.

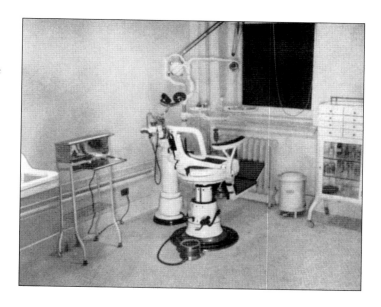

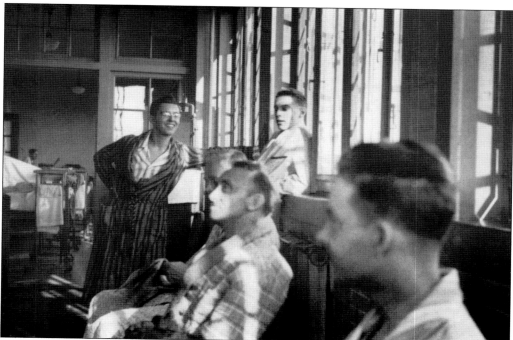

Although the county's enlargement of the sanatorium did initially reduce the number of those who awaited entry into the institution, by 1935, the waiting list was again at 80 patients. When recommendations for further expansion were denied by the county, the open porches along the top floor of the Hospital Building were enclosed to allow for the accommodation of 24 more patients. On July 1, 1936, these additional wards were opened, and the sanatorium's bed capacity was increased to 446. (Courtesy of North Caldwell Historical Society.)

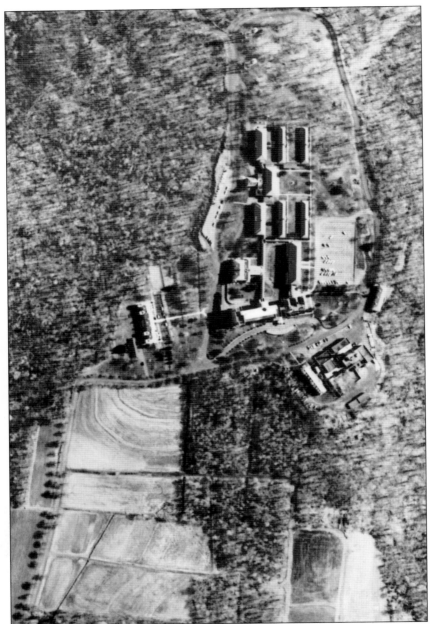

The sanatorium grounds had grown to nearly 300 acres by the time of this aerial photograph. The facility's rural, wooded site was ideal, as it allowed for the isolation of the afflicted and also for the development of outdoor space, which was used for patient recreation and exercise. Note the vast farmland that occupied the southwestern portion of the lands, where the institution would grow its own vegetables. The farm was worked by prisoners of the penitentiary in North Caldwell, which also supplied the institution with large quantities of fresh eggs, cheese, chicken, pork, and lamb from their hennery, piggery, and farm. The surplus of food grown in the summer months was frozen, and vegetables were canned for winter use. (Courtesy of Essex County Department of Public Works.)

Four

Greetings from "The San"

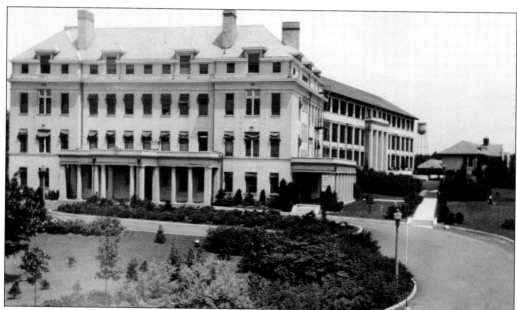

In the early 1900s, postcards were a source of civic pride. Towns would highlight their public buildings, including hospitals and insane asylums, marketing themselves as good places to live, work, and visit. While the idea of promoting such institutions may seem odd today, communities of that era boasted of their modern facilities, and as a result, many postcards of the sanatorium exist. Although the exact date of the above postcard is unknown, it is presumably from the mid-1920s before construction of the new Hospital and Community Buildings.

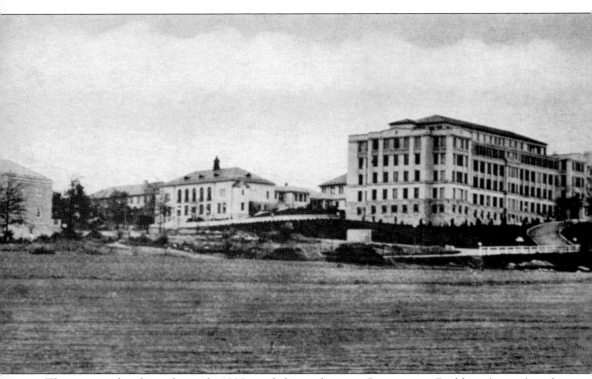

This postcard is from the early 1930s and shows the new Community Building (center) and Hospital Building (right). The large field in the foreground is the sanatorium's farm. In online auctions, this card can sometimes be seen labeled as Essex County Sanatorium, Essex County Hospital, or, mistakenly, Essex County Penitentiary.

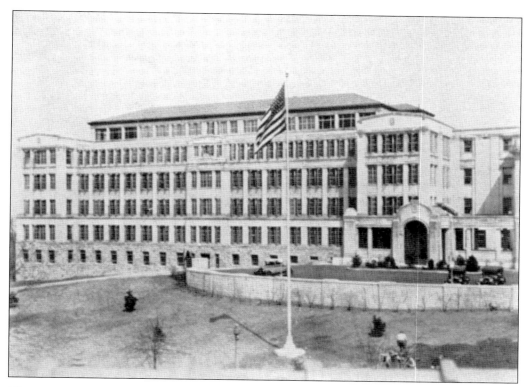

The postcard of the new hospital wing above is labeled "Essex Tuberculosis Hospital 1930." Note the old cars in the parking area. Although overgrown with vines and ivy, the sanatorium's flagpole still stands on the grounds as of 2013. The postcard below is of the original Hospital Building, later referred to as the Infirmary, and is believed to be from the mid-1920s.

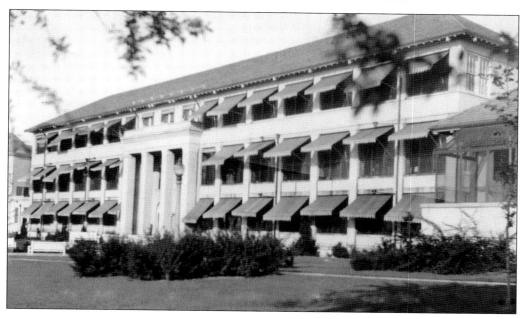

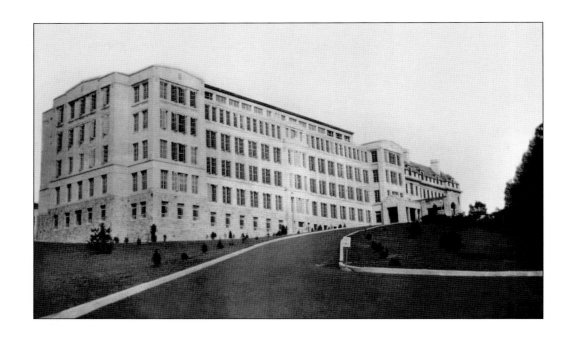

Both the postcard of the Hospital Building, above, and that of the dining hall, annex, and Pavilion C (sometimes referred to as "Ten"), below, were made by the Essex Mountain Sanatorium's occupational therapy department and were available for purchase by patients, employees, and visiting family and friends through the sanatorium store. (Both, courtesy of Robert L. Williams.)

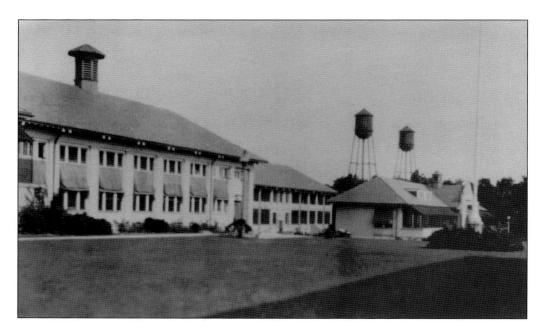

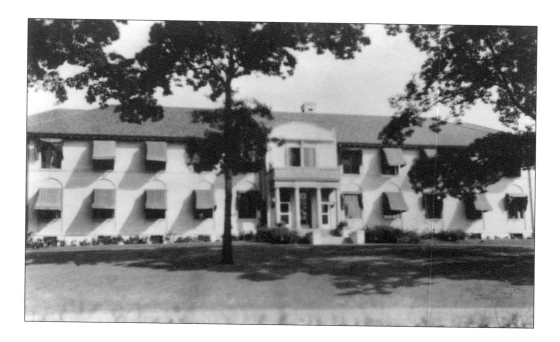

Both the postcard of the nurses' residence, above, and that of the Hospital Building, below, were also made by the Essex Mountain Sanatorium's occupational therapy department. Although it may be difficult to see in the photograph below, nearly every window of the Hospital Building is open, which was required under the institution's guidelines. Any patient that closed a window without permission was subject to reprimand. (Above, courtesy of Robert L. Williams; below, courtesy of Wilbur F. Jehl, MD.)

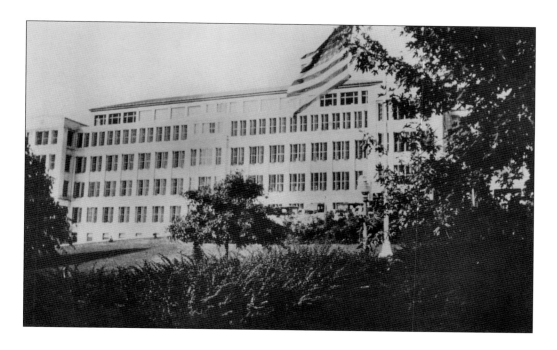

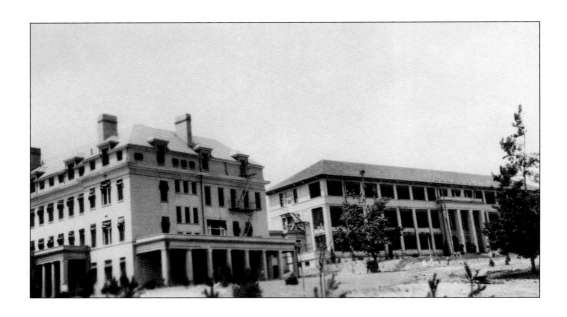

The above postcard was mailed from Verona, New Jersey, to Estonia in June 1925 and was purchased back from that country in an online auction in the early 2000s. The aerial postcard below is believed to be from the 1940s. Note the large coal bunker located behind the Boiler House at the bottom of the image. Coal would be loaded into the building by an elevated crane runway system. (Above, courtesy of Robert L. Williams; below, courtesy of Wilbur F. Jehl, MD.)

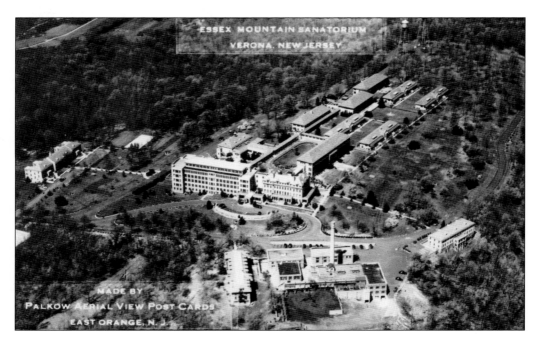

Five

SANATORIA

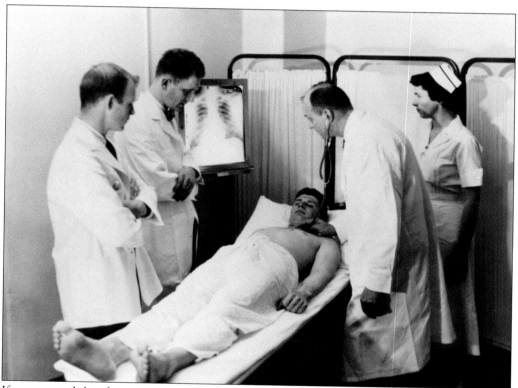

If a person exhibited symptoms suggestive of TB, including a prolonged bloody cough, low-grade fever, chills, drenching night sweats, appetite loss, and significant weight loss, they would be given a tuberculin skin test to check for exposure to the disease. If positive, a chest X-ray would be given, and a clinical specimen—most often from sputum—would be taken from the patient. A diagnosis was only classified as "probable" or "presumed" unless *Mycobacterium tuberculosis* could be cultured from that specimen. (Courtesy of the National Library of Medicine.)

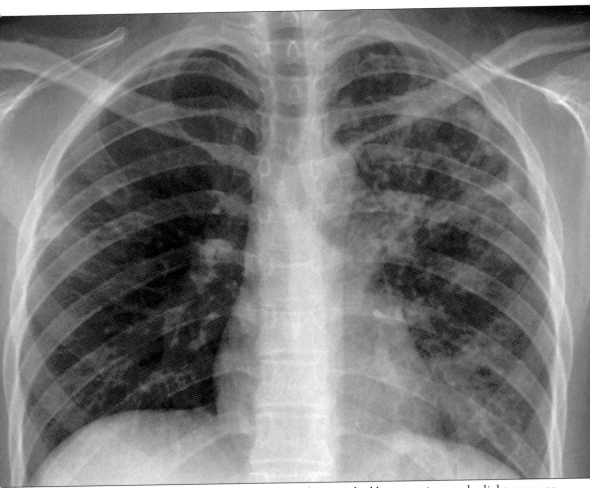

This chest X-ray shows active pulmonary tuberculosis marked by extensive patchy light areas, or opacities, of varying size that run together, particularly on the right. These lesions could appear anywhere in the chest, but abnormal cavities would more often be seen in the upper lungs. Although X-rays could only suggest that active tuberculosis disease was present, many sanatorium physicians would often order a complete fluoroscopic examination as well. (Courtesy of Wilbur F. Jehl, MD.)

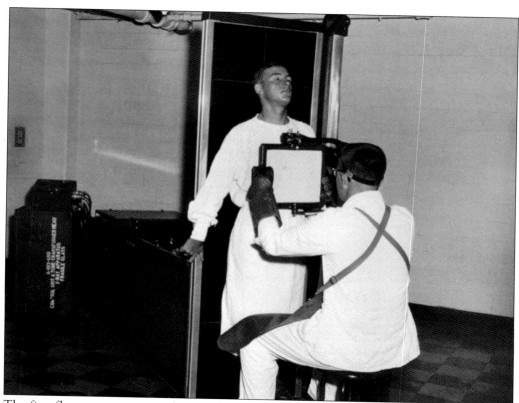

The first fluoroscopes consisted of an X-ray source and fluorescent screen between which the patient would be placed. As the X-rays passed through the body, they would cast a shadow of the different internal structures on the fluorescent plate. Because most of the energy was dissipated as heat, only a fraction of it was given off as visible light. Early radiologists would adapt their eyes to view the dim fluoroscopic images by sitting in darkened rooms, or by wearing red adaptation goggles. Due to their placement directly behind the screen, the radiologist received significant doses of radiation during these procedures. (Courtesy of the National Library of Medicine.)

All members of the family and close associates of the patient were required to report to the sanatorium to have chest X-rays and were obligated to return every six months. If results were all negative at the end of the year, they could report annually thereafter. These testing programs, which were subsidized by the state and run by the county, were free to the families. (Courtesy of Verona Public Library.)

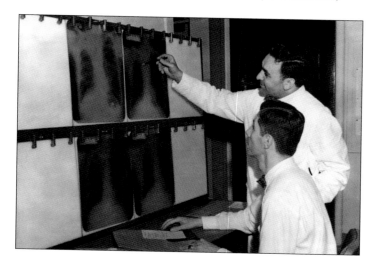

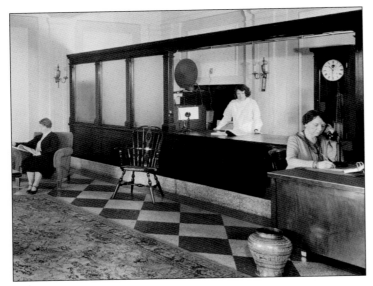

Laws concerning tuberculosis were very strict at the time. If a resident of Essex County was diagnosed with TB, they could be removed from their loved ones and forced to enter the institution. At arrival, the patient would be assigned to the entry ward until a complete estimation of their condition was made and treatment was decided on. Visiting hours were on Sunday but only behind a glass partition. (Courtesy of Wilbur F. Jehl, MD.)

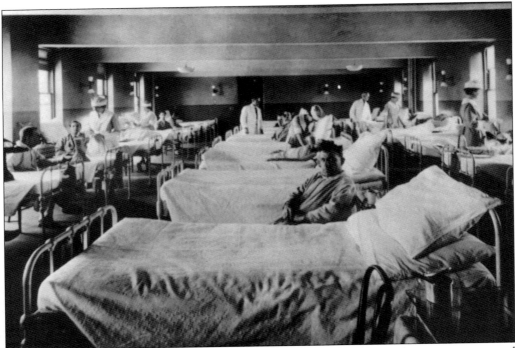

Personal possessions were not allowed in the entry ward as space was limited. Patients were issued hospital gowns, which solved the problem of laundering and returning the correct pajamas to their respective owners, and it also discouraged them from running away. Although most people were very ill, some would try to escape. If they left without permission, the police would return them to the sanatorium, where they would then be confined to a locked ward. (Courtesy of the National Library of Medicine.)

ESSEX MOUNTAIN SANATORIUM

Every one entering the Institution subscribes to the following

RULES FOR PATIENTS

I. Patients upon admission must not leave the building until they have received instructions from their physician. They are required to follow the advice of the physician regarding dress, exercise and diet.

II. Patients are required to use at all times for expectoration, the cuspidors and flasks provided for that purpose. Spitting upon the ground, floors or into basins, closets or sinks is prohibited.

III. Patients must spend as much time as possible out of doors. They must be out of the wards before 9 o'clock A. M. The daily life must be spent out of doors.

IV. Patients must be present at all meals and lunches unless excused by the Superintendent or physicians. Patients must respond promptly to the bell for meals and the hands must be thoroughly cleansed before entering the dining room. Eating between meals and lunches is prohibited.

V. The use of tobacco is discountenanced. Smoking is prohibited in all toilets and in all buildings at all times.

VI. The use of alcoholic liquor of any kind except by prescription is prohibited and will be punished by dismissal.

VII. Patients must be in bed before 9.30 P. M., at which time all lights are turned off. After that time absolute quiet must prevail.

VIII. Conversation between patients regarding their symptoms or any subject relating to illness should be avoided at all times. Be patient, cheerful and hopeful. Do not allow yourself to become depressed because you do not get well at once.

IX. The time between 1.00 and 3.00 P. M., daily must be observed as a "quiet hour" in the wards. During this time all talking, passing through the wards, or other disturbing noises must be avoided.

X. Blankets next the body in sleeping are not allowed.

XI. All windows are to be opened and closed by permission only.

XII. Association of men and women on or off the grounds is not permitted except by permission.

XIII. Patients will be held responsible for any damage to the property of the Institution. Charges for breakage and repairs will be made on the monthly account.

XIV. Walks must be confined to Sanatorium lands. Under no circumstances are fires to be lighted on the grounds or in the woods. Mutilating the woodland in any manner is prohibited. Patients are requested to do all in their power to preserve the trees, wild flowers, etc.

XV. A careful, regular life is required of all, and for any violation of the rules or for obnoxious conduct about the Institution, on the grounds, along the roadways, in the village or elsewhere, the patient may be punished by dismissal.

XVI. Patients are required to give the Superintendent three days' notice before departure.

XVII. Patients will not be allowed to leave the Institution temporarily except for urgent reasons and then only for a limited absence, and after obtaining permission from the Superintendent. At such times they must provide their own conveyance to and from the station and pay for board and treatment during their absence.

XVIII. The Sanatorium will not be responsible for any articles of jewelry or money not checked in the safe provided for that purpose.

Those admitted were issued a "Rules for Patients" form, which introduced them to the strict regiment of sanatorium life. Ambulant patients were ordered out of the wards by 9:30 a.m. and needed to be back in bed by 9:30 p.m. Observation of "quiet hour" in the afternoons was mandatory for everyone, including staff. Patients were to be present at all meals and respond promptly to serving bells. Cloth handkerchiefs were considered contraband, and spitting was only allowed in personal spit cups or cuspidors. Tobacco and alcohol were off-limits, as was the association of men and women. There were also strict rules forbidding conversations about illness, disease, or symptoms. Death was not to be discussed, and individuals would mourn the loss of a friend in private, as memorial services were not allowed at the sanatorium. Patients were told to keep an optimistic outlook about their condition to avoid becoming depressed. "Be patient, cheerful, and hopeful." (Courtesy of North Caldwell Historical Society.)

ESSEX MOUNTAIN SANATORIUM

MENU FOR WEEK BEGINNING OCTOBER 3, 1938

MONDAY

Breakfast–	Dinner–	Supper–
Stewed Figs	Barley Soup	Broth
Cream of Wheat	Rib Roast	Meat Stew
Corn Flakes	Mashed Potatoes	Lettuce
Ham Omelet	Wax Beans	Cake
Corn Bread	Sago Pudding	Milk, Tea, Coffee
Milk, Coffee	Milk, Tea, Coffee	

TUESDAY

Breakfast–	Dinner–	Supper–
Bananas	Vegetable Soup	Broth
Farina	Roast Hamburg	Sirloin Steak
Puffed Wheat	Parsley Buttered	French Fried
Boiled Potatoes	Potatoes	Potatoes
Griddle Cakes	Egg Plant	Lettuce
Milk, Coffee	Apple Pie	Cake
	Milk, Tea, Coffee	Milk, Tea, Coffee

WEDNESDAY

Breakfast–	Dinner–	Supper–
Stewed Prunes	Bean Soup	Broth
Corn Meal Mush	Roast Veal	Pork and Veal Chops
Shredded Wheat	Mashed Potatoes	Boiled Sweet Potatoes
Scrambled Eggs	Buttered Beets	Lettuce
Rolls	Tapioca Pudding	Cake
Milk, Coffee	Milk, Tea, Coffee	Milk, Tea, Coffee

THURSDAY

Breakfast–	Dinner–	Supper–
Stewed Peaches	Cream of Tomato	Broth
Oatmeal	Baked Ham	Veal Cutlet
Puffed Wheat	Boiled Potatoes	Baked Potatoes
Poached Eggs on	Cabbage	Vegetable Salad
Toast	Rice Pudding	Cake
Milk, Coffee	Milk, Tea, Coffee	Milk, Tea, Coffee

FRIDAY

Breakfast–	Dinner–	Supper–
Bananas	Clam Chowder	Oyster Stew
Cream of Wheat	Halibut	Italian Spaghetti
Grape Nuts	Mashed Potatoes	Sardines
Omelet	Lima Beans	Apple Sauce
Milk, Coffee	JELLO	Cake
	Milk, Tea, Coffee	Milk, Tea, Coffee

SATURDAY

Breakfast–	Dinner–	Supper–
Stewed Rhubarb	Puree of Jackson	Broth
Hominy	Roast Lamb	Liver and Onions
Corn Flakes	Boiled Potatoes	Delmonico Potatoes
Fried Eggs	Mashed Turnips	Lettuce
Graham Muffins	Corn Starch	Pineapple
Milk, Coffee	Pudding	Cake
	Milk, Tea, Coffee	Milk, Tea, Coffee

SUNDAY

Breakfast–	Dinner–	Supper–
Stewed Prunes	Vegetable Soup	Broth
Oatmeal	Roast Chicken	Cold Meats
Puffed Wheat	Mashed Potatoes	Dutchess Potatoes
Boiled Eggs	Cauliflower	Lettuce
Coffee Cake	Ice Cream	Apricots
Milk, Coffee	Milk, Tea, Coffee	Cake
		Milk, Tea, Coffee

Upon entry to the institution, most people were underweight and malnourished. Diets high in fat and calories were believed to promote weight gain and good nutrition, and as a result, rich, fatty meals containing butter, cream, and pork lard were common in sanatoriums, with fresh milk being "preferable to all other kinds of food." Because consumptives also suffered appetite loss, eating between meals was prohibited, and palatable, visually appealing dishes were important. Patients were required to eat, so menus were carefully planned, and monotony was avoided by offering a wide variety of foods, with no meals repeated on consecutive days. Although staples of sanatorium diets were offered routinely, they would often be cooked or prepared differently.

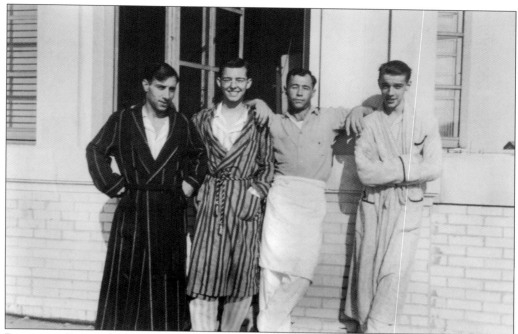

Patients well enough were required to spend as much time out of doors as possible. A daily life outside often included light activities or games, walks amongst the lands, and time spent in cure chairs relaxing, reading, and socializing on the sanatorium's lawns and sun decks. Covered porches were utilized in rainy or snowy weather. For those who could not afford the thick and heavy robes, jackets, slippers, and gloves that were necessary for outdoor winter life, the institution received gifts and donations throughout the year, both unsolicited and from clothes drives. These photographs show ambulant tuberculous patients, or "lungers," posing on the western heliotherapy deck in the spring of 1940, with a Vita Glass room in the background. Note the terra-cotta tiles used on the deck. In the 1950s, these were removed, and the decks were covered with standard tar and gravel roofing materials. (Both, courtesy of North Caldwell Historical Society.)

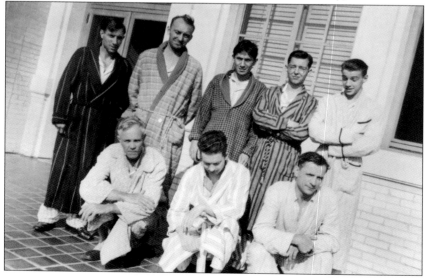

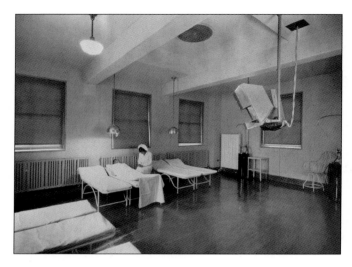

Although the value of heliotherapy in the treatment of pulmonary tuberculosis was debatable, most physicians thought it could be of benefit if given in proper doses. On cloudy days, exposure to the UV spectrum was obtained by artificial light from mercury vapor-bulbs, such as Kromayer or Alpine lamps. Tubes could be attached to these lamps through openings in the shade, allowing inhalation of the ozone produced. (Courtesy of Wilbur F. Jehl, MD.)

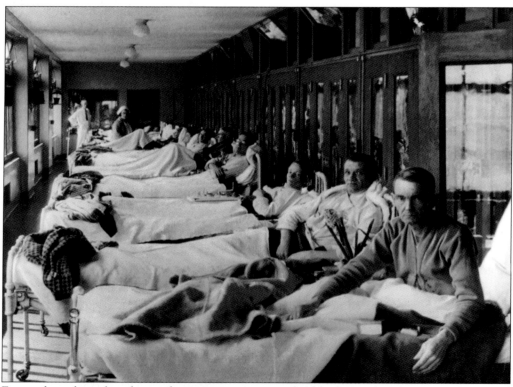

For moderately or far advanced cases, treatment involved bed rest. Any movement increased lung use, so complete inactivity was ordered. Patients who were very ill were not allowed to sit up except for eating and using the bedpan. Maximum exposure to fresh air was necessary to provide as much oxygen to the damaged lungs as possible. Those confined to bed would often be wheeled out onto open porches, both in winter and summer, regardless of temperature. (Courtesy of Library of Congress.)

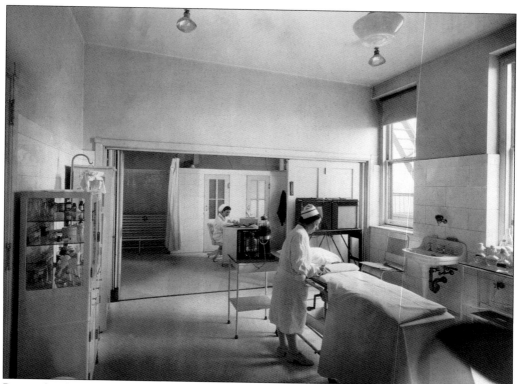

Pictured is the sanatorium's pneumothorax room. Over half of all patients received some form of collapse therapy, which deflated a lung and allowed it to rest and heal. Pneumothorax involved the injection of nitrogen into the chest cavity through a puncture or incision until the lung collapsed, essentially squeezing the organ out like a sponge and allowing for the emptying of tubercle cavities. The gas would slowly be absorbed by the body, however, reversing the procedure. Numerous treatments were required to keep the lung collapsed for one to several years. (Courtesy of Wilbur F. Jehl, MD.)

A Robinson Pneumothorax Apparatus was used to perform the procedure at the sanatorium. It was fitted with two bottles and several valves, which together made a manometer, allowing the physician to accurately gauge the amount of gas being pumped into the thoracic cavity. By 1936, nearly 40,000 treatments had been given at the facility, with mixed results. (Courtesy of Virginia Commonwealth University.)

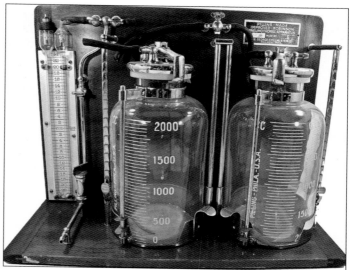

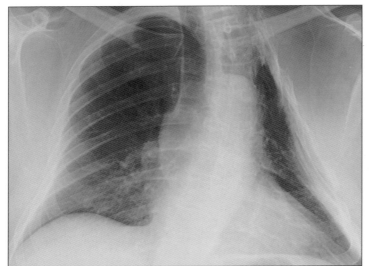

If pneumothorax was unsuccessful, thoracic surgery was performed. Thoracoplasty refers to the removal of 8 to 10 rib bones in order to collapse a lung. Because most surgeons preferred to remove only two or three ribs at a time, several operations were required before the procedure was completed. The X-ray at left shows the scoliosis deformity resulting from thoracoplasty. (Courtesy of Wilbur F. Jehl, MD.)

Oftentimes in thoracoplasty, the upper portion of lung would not adequately deflate. Apicolysis was a technique that surgically detached the apex of the lung from the pleural wall, creating a cavity. Plombage treatment was then performed, filling this space with some inert material that prevented expansion of the lung, forcing the upper lobe to collapse. A variety of substances were typically used, including olive or mineral oil (oleothorax), gauze, warmed lumps of paraffin wax, and Lucite balls (shown in above X-ray). (Courtesy of Wilbur F. Jehl, MD.)

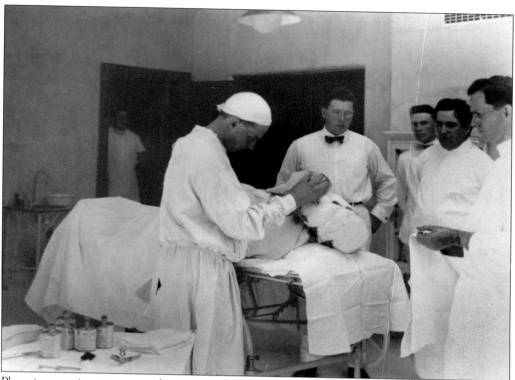

Phrenic exeresis, or nerve crush, was also performed, temporarily disabling half of the diaphragm. The phrenic nerve, which controls contraction of the muscle, would be crushed on one side through an incision made just above the collarbone. The relaxed diaphragm would then rise up in the chest, collapsing the lung. It would remain paralyzed for up to six months, with movement gradually returning. Several "recrushes" would be performed before scar tissue made the operation too difficult. If necessary, a small portion of the nerve was removed, resulting in permanent paralysis of the diaphragm. (Courtesy of Essex County Department of Public Works.)

By the 1950s, surgical removal of a diseased part of the lung (lobectomy), or of an entire lung (pneumonectomy, shown in the X-ray), had become commonplace. These major lung surgeries were approached with hesitation in the late 1930s, however, and were only performed in those cases that could not be controlled by simpler collapse procedures. (Courtesy of Wilbur F. Jehl, MD.)

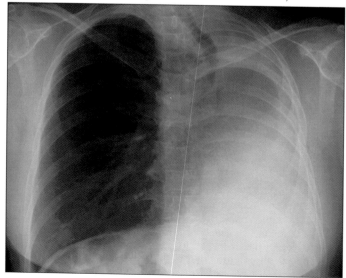

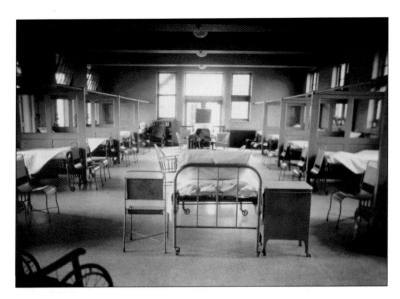

If the patient did not respond well to treatment and continued to deteriorate, they were transferred to Ward D, which was a kind of critical care area. Patients dreaded placement in this ward, which they called "Death Valley;" it often meant succumbing to the disease was imminent. (Courtesy of Wilbur F. Jehl, MD.)

Because a positive frame of mind was believed essential for the cure, staff was responsible for helping patients maintain a cheerful and hopeful spirit at all times, which was no easy task given the seriousness of the disease. As sanatoriums did not offer any official bereavement counseling, doctors and nurses were restricted from informing their charges about the passing of another patient and were required to remain apathetic about death. (Courtesy of Verona Public Library.)

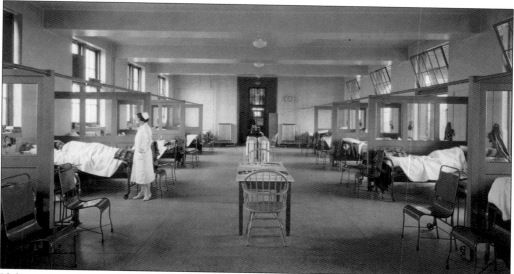

If the patient showed improvement, they were moved to the semi-ambulant ward, which allowed some restricted visitors and a slight amount of activity. At first, they were permitted to sit up to read and write. If they progressed further, bathroom privileges were granted, and patients could change out of their pajamas and eat meals in the dining hall. It was a great day at the sanatorium when one could shower and no longer had to use a bedpan. (Courtesy of Wilbur F. Jehl, MD.)

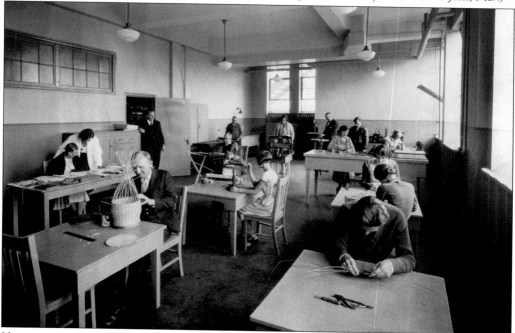

If progress continued, the next ward allowed the patient to be out of bed for longer periods and to take part in more activities. Visiting hours were increased, and arts and crafts classes were introduced. If a patient responded well, they would then be enrolled in occupational therapy, which was designed to combat the boredom and depression of a regimented sanatorium life that could, and often did, become tedious and hard to bear. (Courtesy of Wilbur F. Jehl, MD.)

Pictured in 1932 is the staff of the sanatorium's occupational therapy department. Occupational therapy as a vocation was conceived in the early 1910s as a reflection of the Progressive Era. It was officially named in 1920, and the profession obtained medical legitimacy by the end of the decade. Educational guidelines and accreditation procedures had been established by the date of this photograph.

These are actual baskets and trays made by the sanatorium's occupational therapy department. Craft products were displayed and sold in the hospital's main lobby, the sanatorium store, and in display cases throughout the halls of the Community Building. Large numbers of sales would be made through local craft fairs held throughout the year, with all profits being received by patients.

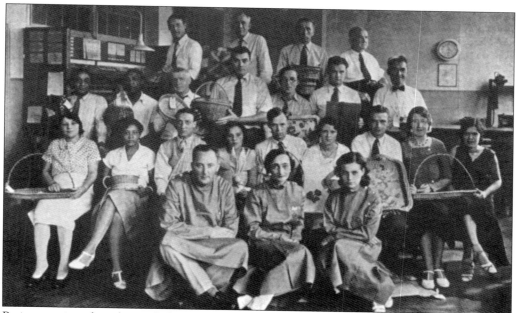

Patients assigned to the craft department were also responsible for decorating the sanatorium during the different holiday seasons and making small gifts for each occasion. Easter baskets were woven, Thanksgiving and Christmas trays were filled with favors, and candy boxes were made for Halloween and New Years Day. Other projects by the craft shop included the construction of decorative window lambrequins and flower boxes for the institution.

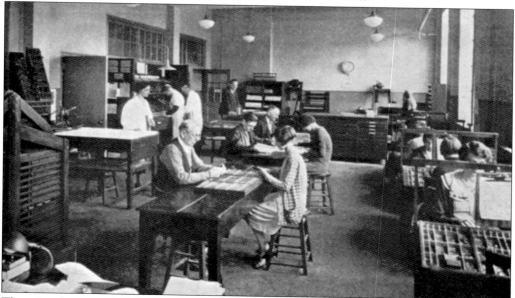

The print shop was the major occupational therapy activity and was responsible for the printing of the institution's official letterhead and other stationary as well as miscellaneous memos and dining hall menus. During the holiday season, special Christmas cards would be printed out and sent to various organizations and distributed to patients and employees. The department's main task, however, was the publication of the sanatorium magazine, the *Buzzer*.

ESSEX MOUNTAIN SANATORIUM

Beauty is a witch,
Against whose charms faith melteth into blood.
—Shakespeare

The sanatorium magazine, the *Buzzer*, was published on the first day of each month throughout the year. Early editions were 20 pages in length, with special-feature issues of 38 pages printed in both April and August. An average of 10,000 copies were sold annually and sent to institutions all over the world, including 92 sanatoriums, 71 general hospitals, and several training schools. Because the publication was full of positive articles, slogans, and messages, many educational organizations used it as health propaganda. Note the quote, "Beauty is a witch, / Against whose charms faith melteth into blood" from Shakespeare's *Much Ado About Nothing*, a play in which one of the characters is mistakenly believed to be dying of "a consumption."

"The Buzzer" is printed and published in its entirety in "The Buzzer's" own printing plant located in the Community Building of the Essex Mountain Sanatorium, at Verona, N. J., as an occupational therapy activity, and is issued on or before the first day of every month.

All of the reading and advertising matter is collected, edited, set by hand, the pages locked up, made ready for the press, finally being fed into the press and printed by patients, who, by the advice of the medical staff, have engaged in this work for the betterment of their health.

VISITING DAYS . . . SUNDAYS . . . AND . . . HOLIDAYS . . . Between the hours of 2 and 4 P. M.
WEDNESDAY NIGHTS . . . Between the hours of 7 and 9 P. M.

VOL. 10. NO. 12. Essex Mountain Sanatorium, VERONA, N. J., NOVEMBER, 1933 PRICE TEN CENTS

THREE WOMEN AND A SANATORIUM

Being a Brief History of the Founding and Development of the Essex Mountain Sanatorium.

By W. M. Harman

EW of Essex County's citizens know the purpose for which the stately group of buildings, crowning Second Mountain, is maintained. While few if any of the four hundred and fifteen patients sheltered within its walls, have the slightest conception of the collossal difficulties surmounted to provide the care they now accept as a matter of course.

The green roofs of the buildings on Second Mountain of the Watchung range, visible for miles on a clear day, cover a modern sanatorium for tuberculous disease, wherein are all the appliances for scientific diagnosis and treatment together with a sufficient number of beds to accommodate four hundred and fifteen of the counties tuberculous sick. For this magnificent institution and the work it does, the sick of this county are indebted to the interest and enterprise of three women. It required two women to arouse the public to recognition of the deplorable condition of the victims of tuberculous disease; the practical vision of a woman to choose the best

available site for a Sanatorium; the courage and determination of both to force the acceptance and solution of this acute problem. When another crisis arose as to expansion and development, it was a woman who stepped forward to demand that this development be made to cover the whole of the county tuberculosis problem in the process of its expansion.

It is this story, taken largely from newspaper clippings yellow with age, and retold by the women who, having accomplished their work returned to their own interests or took up new problems of public welfare, that has decided the title chosen in recounting these forgotten incidents.

In February 1907 the husband of a laundress, working for Mrs. Edwin A. Prieth of Montclair was acutely ill of tuberculous disease and the family was in distress. The sick man was a resident of the City of Newark and Mrs. Prieth and her friend and neighbor, Miss Mary Wilson (now Mrs. Thomas Travis of 149 Watchung Avenue, Montclair) applied to the Board of Health of that city for assistance in making some disposition of the case. The Board of Health was sympathetic but helpless. There were no facilities for caring for tuberculosis at the disposition of the city. The president of the Board of Health, Dr. Herman C. H. Herold explained the helplessness of his Board to cope with the problem unless proper facilities were provided and detailed the pitiful condition of various tuberculous patients for whom the Board was doing all that was in their power with existing facilities. Later, at a meeting of the City Council Dr. Herold summed up the situation briefly, "I came here to tell

you how inadequate are our accommodations for the care of tuberculous patients, both indigents and those who can pay for their treatment. St. Michael's and the City Hospital are the only two institutions in the City that receives tuberculous patients. The Home for Crippled Children takes bone tuberculosis patients, but will not take persons suffering from pulmonary tuberculosis. The question of caring for consumptives is being agitated all over the country, but we have had to lie low and say nothing because we have no adequate means for treating sufferers from the disease.—There were 842 deaths from tuberculosis in Newark last year—there is no doubt but that many of those who died in 1906 had been sick for a number of years. There are now in the city at least 3,000 cases of tuberculosis. Just how many there are it is impossible to state, because the disease is unreportable."

This summary of the condition of the tuberculous sick in Newark came after Mrs. Prieth and Miss Wilson had satisfied themselves that conditions were appalling and devised a plan, which seemed practical to them for an immediate solution of the problem.

Deciding that if things were as bad as the Board of Health represented it something should be done about it, they visited one of the consumptives for whom the Board was doing what they could. They found a young hatter dying of the disease in the basement of a downtown restaurant, unattended, without money, his only food such as the charitable owner could give him, his only bedding a Board of Health blanket. Having

(Continued on page 10)

TUBERCULOSIS IS CURABLE!!

By 1933, the *Buzzer* had expanded to 24 pages, and the cover was standardized in color and border design. It maintained its place as a leader amongst these types of publications, and subscribers now included every sanatorium in the United States and three in Canada. It received special commendations from eminent authorities of the day, such as Dr. Lawrence Flick of Philadelphia, the National Tuberculosis Association, and the *Journal of Outdoor Life* magazine, which would often reprint original articles written by the sanatorium physicians. Patients were encouraged to contribute material as well, and many would submit columns of lighthearted gossip, poetry, and jokes, while others would act as reporters and write about issues pertaining to their respective wards.

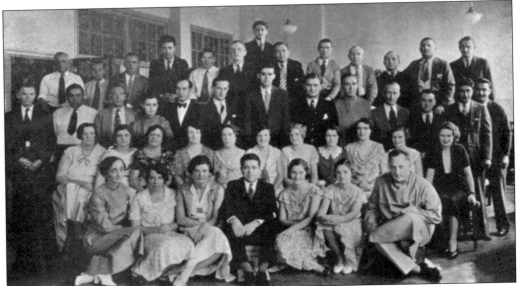

In the mid-1930s, the American Occupational Therapy Association emphasized that the trend in therapy should be away from crafts and more toward purposeful occupation. The printing department not only taught patients a trade that prepared them to resume working upon their release, it also gave those who lacked an education the opportunity to acquire a better knowledge of the English language.

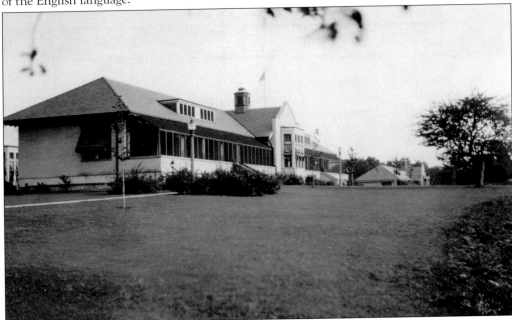

The sanatorium's three distinct zones allowed patients to move through the institution as they recovered. With improving health, their progression through the hospital, semi-ambulant, and ambulant wards would culminate with movement into the shacks, which were small, independent outbuildings on the periphery of the main complex where patients lived together in small groups and were granted "run of the grounds" privileges. (Courtesy of Wilbur F. Jehl, MD.)

Patients assigned to the shacks were entirely responsible for themselves and needed to make their own beds and keep the place clean. This pencil sketch shows the miniature golf course, which would be set up on the shack lawns in the summer months along with other outdoor games. As these cottages were not connected to the complex by corridors, patients used outdoor walking paths to reach the other buildings of the facility, such as the dining hall for their meals. (Courtesy of Wilbur F. Jehl, MD.)

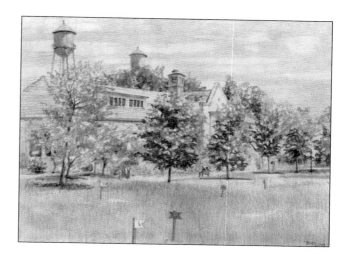

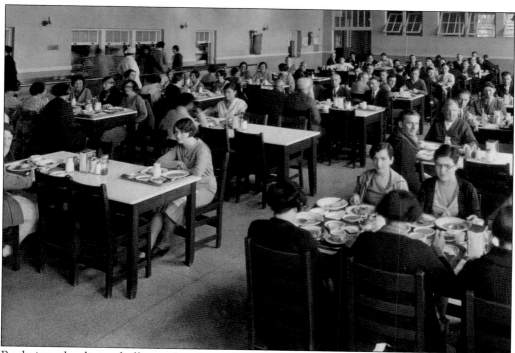

By design, the dining hall was placed at a distance from the patients' living quarters. This was done to promote the light exercise of walking and to also avoid further aggravating patients' loss of appetite with the constant smell of cooking. Note the half-pint milk bottles on the tables; they could be found scattered throughout the former sanatorium grounds until recently. The large wall to the left would receive a Works Progress Administration (WPA) mural in 1936. (Courtesy of Wilbur F. Jehl, MD.)

Because it was large and uninterrupted by windows, the 75-by-16-foot wall seemed impossible to decorate until the WPA, which provided work for unemployed artists, informed the sanatorium committee that a mural could be created without any expense to the county except for the cost of paint. A design competition was held in July 1935, and from the sketches submitted to the board of freeholders, Michael Lenson (pictured) was chosen as the artist. (Courtesy of Barry Lenson.)

Work began immediately, with the first two months being devoted to researching the project, enlarging the design, "sounding out" the wall, and mounting the huge canvas. Actual painting started in mid-September 1935. While many murals of the day were created in an artist's studio and then transported to their permanent location, painting of *The History of New Jersey* was done entirely at the sanatorium with the use of scaffolds. (Courtesy of Barry Lenson.)

The mural, which took Lenson and his staff of four assistants a year and a half to complete, was comprised of three separate sections. The 18-by-14-foot left panel (above), titled "Indian Settlers' Arrangement," depicted Indians trading with Dutch settlers and Robert Fulton's steamboat on the Hudson. The right panel (below), also 18 by 14 feet, was named "Molly Pitcher and Revolutionary Soldiers" and showed colonial troops and the Morristown headquarters of George Washington. (Both, courtesy of the Wolfsonian, Florida International University.)

The mural's central panel, titled "Farm and City," measured 36 feet by 14 feet and represented the modern development of New Jersey in agriculture, industry, and transportation, with skyscrapers, airplanes, and the steamship *Normandie* in the background. The entire mural together was 1,044 square feet, making it one of the largest put up by the WPA project in the country. The completed mural was unveiled at a ceremony held at the sanatorium on the afternoon of November 19,

1936. Invitations were sent to WPA and Essex County officials and civic leaders, and an open invitation was issued to the public. Tea was served after the painting was formally presented to the institution, and the hospital was opened for inspection by guests. (Courtesy of the Wolfsonian, Florida International University.)

The goal of all patients was to reach the point in their treatment where they were permitted to go home for a visit. If a shack resident had a spotless record for cooperation and their health was excellent, they could apply for a weekend pass. If all rules were followed and they returned on time, passes were allowed every weekend. If their health continued to improve, the patient was released. (Courtesy of North Caldwell Historical Society.)

In the era before antibiotics, the most to be expected was to arrest the disease, as there was no hope of achieving an absolute cure. After a patient was released from the sanatorium, some possibility of a relapse would always exist throughout their lifetime. Since 90 percent of all relapses occurred within three to four years after returning home, regular check-ups were required for the patient and their families.

Six

A NEW HOPE

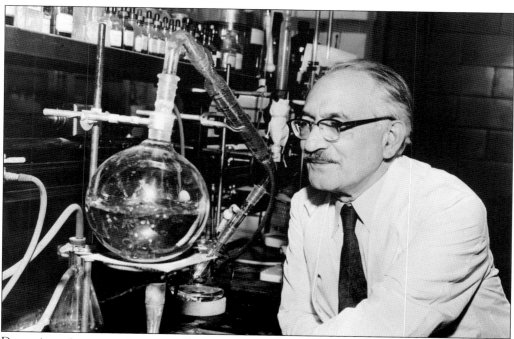

Due to its resistance against penicillin, many scientists of the early 1940s believed *Mycobacterium tuberculosis* contained some peculiar feature that rendered it immune to chemotherapy. The first antibiotic to be found effective against the bacteria was streptomycin, which was isolated from a pot of farmyard soil on October 19, 1943, in the laboratory of Selman Waksman (pictured) at Rutgers University, New Jersey. Known as the "second great antibiotic," streptomycin became the first medicinal remedy for pulmonary tuberculosis, making the effective treatment and cure of the disease a reality. The drug was not without its downfalls, however; it could not be given orally and could only be administered by regular intramuscular injections, and results were beginning to show acquired bacterial resistance to the drug. In 1952, under a storm of controversy, Selman Waksman was awarded the Nobel Prize as its sole discoverer. (Courtesy of Library of Congress.)

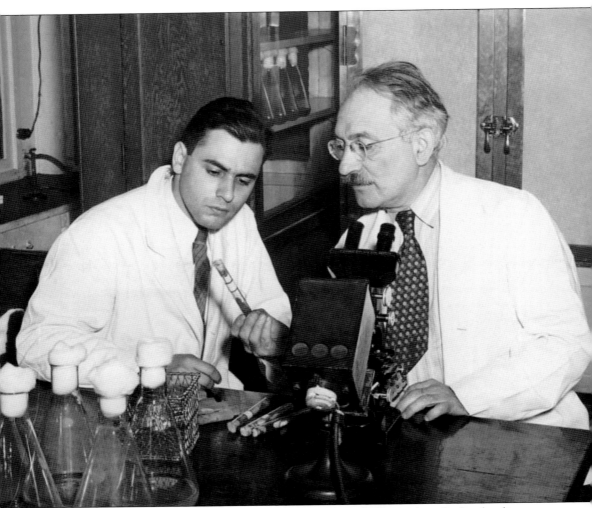

Having initially given his graduate student Albert Schatz (left) equal credit for the discovery, Waksman (right) slowly began dropping Schatz's name from papers; he also negotiated a secret royalty deal to receive hundreds of thousands of dollars from the patent that he and Schatz were awarded. A legal battle ensued, and Schatz was eventually recognized as codiscoverer and given a share of the royalties, but the scientific establishment sided with Waksman. The Nobel committee ruled that Schatz was a mere lab assistant working under an eminent scientist, and Schatz disappeared into academic obscurity. Although the discovery of streptomycin is generally considered the beginning of the modern era of effective tuberculosis treatment, better results followed with the development of the first oral agents, such as para-aminosalicylic acid (PAS) in 1949. However, the true revolution would begin some years later in 1952 with the development of isoniazid. Early preparations of isoniazid had a stimulant effect, resulting in formerly gravely ill patients "dancing in the halls," which contributed to its reputation as a wonder drug. (Courtesy of Rutgers University Libraries.)

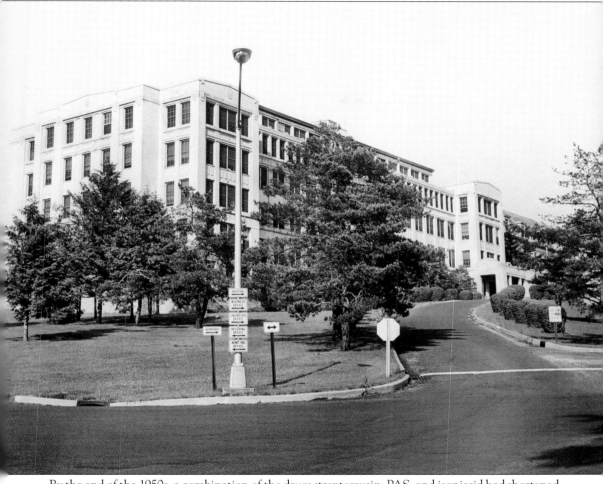

By the end of the 1950s, a combination of the drugs streptomycin, PAS, and isoniazid had shortened the duration of treatment for tuberculosis and markedly decreased the number of people with the disease. Although the pharmaceutical remedy did not produce a rapid cure, studies showed that the effects of the drugs were the same whether they were taken while resting in a sanatorium or while carrying on with a regular life at home. They also showed that the risk of contagion to relatives and others close to those afflicted was very limited once drug treatment began, either in a hospital or at home, which effectively ended the sanatorium age. With the century-old traditions of bed rest, fresh air, and isolation rendered obsolete, patient populations declined and institutions closed rapidly. Essex Mountain Sanatorium was no exception, and its last tuberculosis patient was released in October 1970. (Courtesy of Wilbur F. Jehl, MD.)

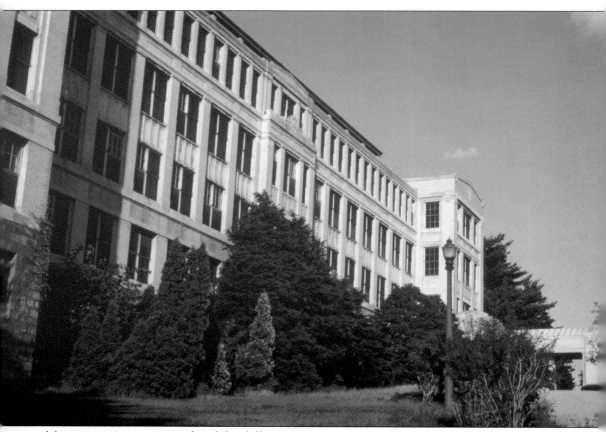

Many institutions were refitted for different purposes or transformed into general hospitals, while others were just simply abandoned or demolished. Essex County College, which had just been recently established, proposed that the hospital could be used for classrooms. The plan was deserted, though, because a few of the building's vacant wards were being used to care for the overflow of senile and harmless chronic patients from nearby Overbrook, the psychiatric hospital located on Fairview Avenue in Cedar Grove. (Courtesy of John Kynor.)

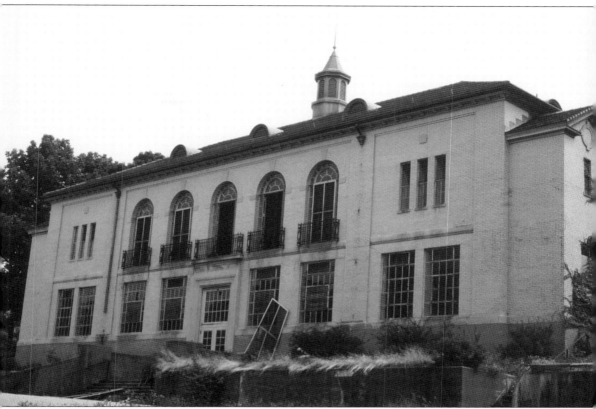

While a few wards did remain active in the hospital, the county struggled to find ways in which to utilize the other structures on the property, such as the Community Building, that were no longer in use and were falling into disrepair. Note the ivy growing on the right side of the building; this type of vegetation would consume much of the abandoned complex in later years. (Courtesy of John Kynor.)

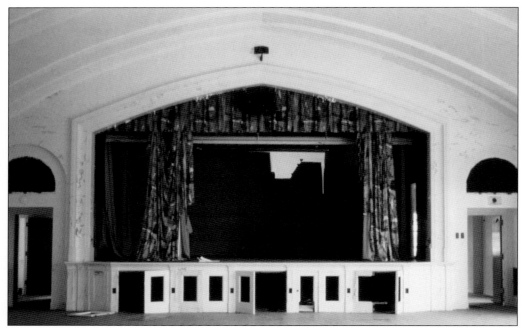

This photograph of an empty auditorium shows the wooden chairs stored under the stage had been removed from the institution, and condensation, due to the lack of heat in the building, was already starting to peel the paint. Also note the torn stage curtain, which was made by patients in the occupational therapy department from donated material in the summer of 1935. (Courtesy of John Kynor.)

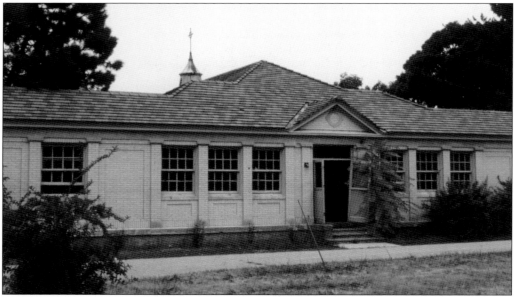

The broken doors of the chapel entrance were indicative of the sanatorium's growing vandalism problem—one that would plague the complex in the future. Note the cupola and wrought-iron halo cross. Although bent by several theft attempts, this cross would remain in place until demolition. (Courtesy of John Kynor.)

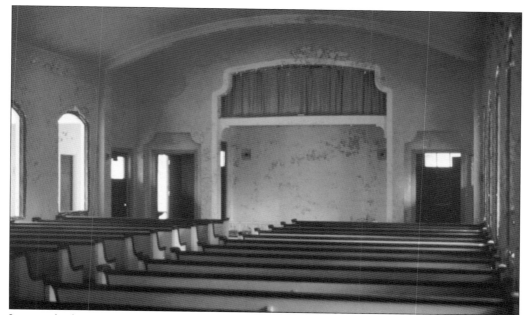

Looting had started, and by this time, the chapel's windows, altar, and organ had been removed. The sanatorium's organ was acquired in 1935 through the charitable efforts of prominent Essex County women, including Mrs. Thomas A. Edison, Mrs. Russell Colgate, and Mrs. Hendon Chubb. (Courtesy of John Kynor.)

The Medical Staff Building (pictured) was appropriated by Overbrook to house some of its doctors and their families. Meanwhile, several of the industrial buildings and garages were used by the county for various purposes, including storage space. (Courtesy of John Kynor.)

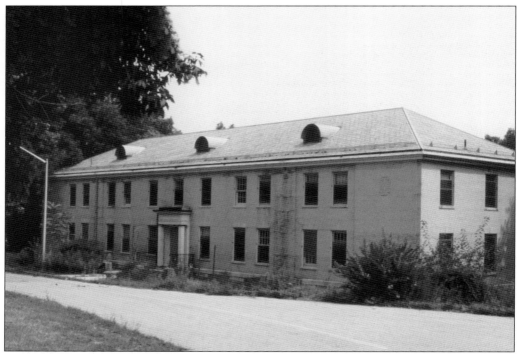

Structures that could not be adapted for different uses sat idle, such as the Female Employee Home (above) on the southeast corner of the property and the Hospital Annex (below) at the northern tip. These two photographs show the county's effort to safeguard these unused buildings was haphazard at best, with the Female Employee Home's front door being boarded up and its windows left unprotected. A few of the Hospital Annex's basement windows were sealed, but no attempt was made to secure the doors. (Both, courtesy of John Kynor.)

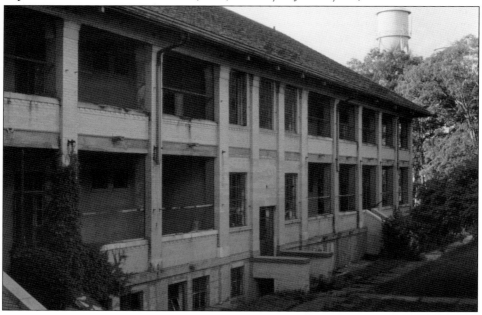

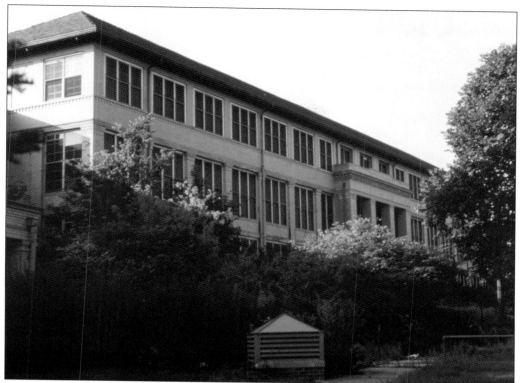

The decorative and functional window awnings had long since been removed from the Infirmary by the time the above photograph was taken. The copper cupola that appears in the foreground is a vent for the underground tunnel that connected the building to the boiler house. The image below is an interior view of one of the Infirmary's two open-air porches that extended off the back of the building into the courtyard. These porches had been enclosed in later years to accommodate additional beds for patients. The corrugated copper roofing that covered these structures was removed early in the institution's abandonment, which led to their quick deterioration. (Both, courtesy of John Kynor.)

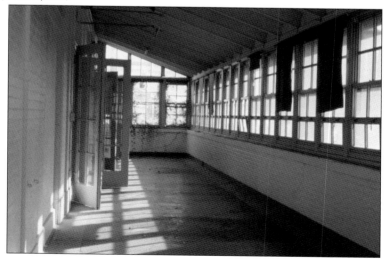

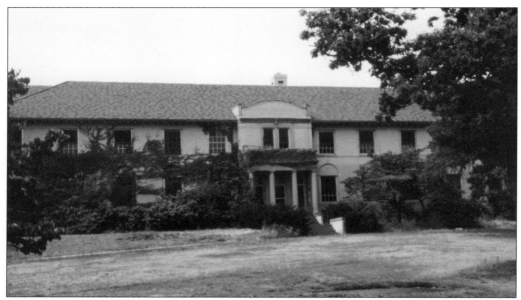

This photograph of the front of an empty nurses' residence (above) was taken from the same angle as the postcard on the top of page 75. Note the ivy beginning to consume the structure, even at this early stage of abandonment. The image of the back of the nurses' residence (below) is similar in angle to the photograph on the top of page 41, which was taken 60 years prior. As can be seen, at some point the long, open veranda along the ground floor was enclosed. There appears to have been no attempt to secure this building, as some windows were left open. (Both, courtesy of John Kynor.)

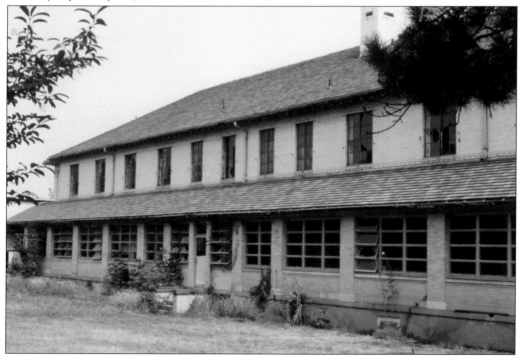

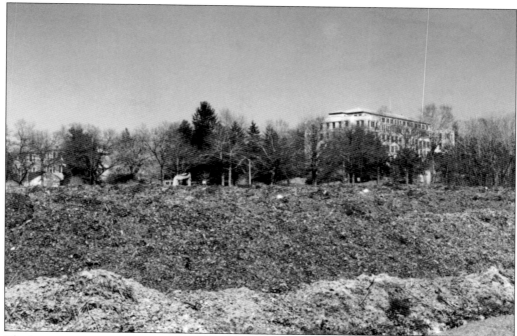

The large, open areas of the sanatorium grounds were used as a compost site for Essex County. The photograph above shows the institution's vast farmland being occupied by long leaf windrows. Note the Medical Staff Building (left) and the Hospital Building (right) in the background. The picture below shows the Infirmary's main parking area was used as well. (Both, courtesy of Carl Sposato.)

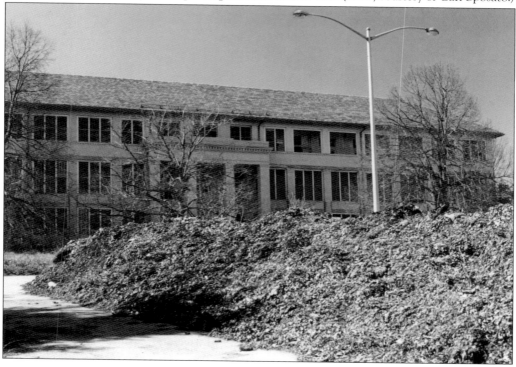

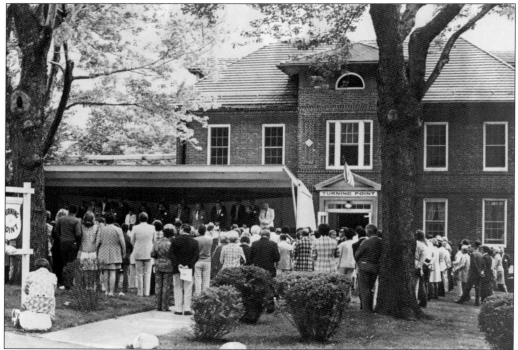

With funds provided by Essex County Freeholders and private donations, Turning Point was established on the Hilltop when the former Male Employee Home was transformed into a 10-bed residential treatment facility for the indigent alcoholic. On St. Patrick's Day, March 17, 1975, a ceremony was held to dedicate the building and officially open the center. (Courtesy of Turning Point.)

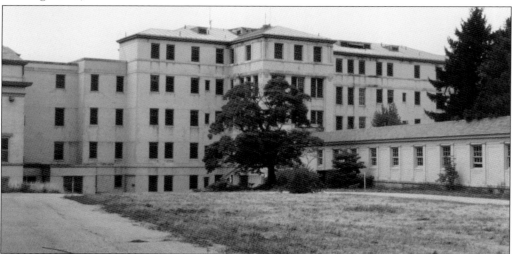

Throughout the 1970s, the introduction of new medications for the treatment of brain disorders meant the deinstitutionalization of psychiatric patients across the nation and declining populations in mental facilities. With additional wards no longer necessary for the care of surplus geriatric Overbrook patients, the Hospital Building officially closed its doors and ceased all operations, and the county abandoned the sanatorium complex on December 1, 1982. (Courtesy of John Kynor.)

Seven

DEATH THROES

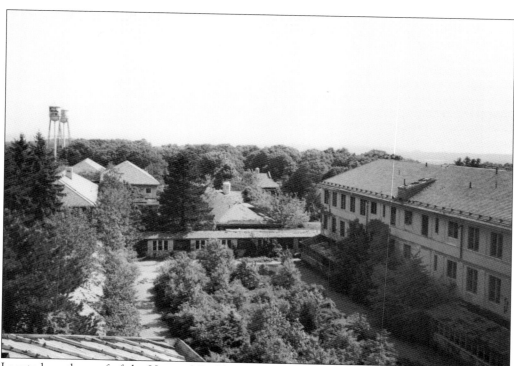

Located on the roof of the Hospital Building, the observation deck, at over 800 feet above sea level, was the highest point in Essex County. From the deck, it was possible to see clear across the state of New Jersey, from the Delaware Water Gap in the west to the twin towers of the New York City skyline in the east. In the 1950s, it was used by spotters for the Civil Defense League to search the skies for enemy Russian planes. This 1991 view from the deck shows decaying buildings and encroaching vegetation. (Courtesy of Bill Minnich.)

After the sanatorium's doors were officially closed in 1982, mystery and superstition began to surround it. Despite its rich history, it operated for over 70 years in relative anonymity, isolated on top of its mountain and largely unnoticed by local residents. This lack of knowledge about the institution led many curiosity seekers to the unsecured buildings, and as word began to spread about the abandoned complex, policing the property became more difficult. This photograph shows the open doors of the institution's main entrance, which led into the main reception area, pictured on page 56. (Courtesy of Robert L. Williams.)

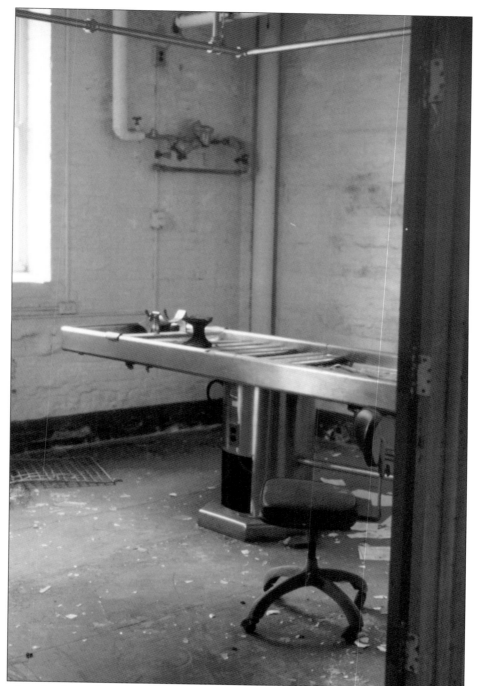

Those imaginative early explorers questioned the sanatorium's abandonment, and rumors of patient mistreatment scandals and of the misappropriation of funds began to surface, as did bizarre tales of barbaric patient experiments. Although they were myths, the fact that the county had left most of the sanatorium's contents behind, such as this autopsy table in the morgue, fueled even more speculation as to the true cause of the sanatorium's closure. (Courtesy of John Kynor.)

Accounts of strange occurrences at the abandoned complex became legendary. Stories of apparitions floating down hallways, brains in jars, satanic cult rituals in the chapel, and escaped lunatics that lived in the underground tunnels added to the sanatorium's notoriety and ominous reputation, making it both a part of local folklore and a true urban legend.

In 1987, the low-budget horror movie *Doom Asylum* was filmed at the abandoned sanatorium complex. The movie, which reportedly took eight days to shoot, starred *Penthouse* Pet of the Year Patty Mullen, *Playboy* centerfold Ruth Collins, and Kristin Davis, who went on to star in Fox's television series *Melrose Place* and HBO's *Sex and the City*. Other notable productions that used the property for filming were the Sylvester Stallone movie *Copland*, Sonic Youth's music video for their song "Candle," and various episodes of *The Sopranos*.

The institution was the subject of controversy for many years, and with estimated costs of millions of dollars for demolition, the county was unsure of what to do with the buildings. A committee was appointed by the county executive to decide whether to tear them down or rehabilitate them for other uses. As the sanatorium awaited its fate, the buildings deteriorated further. This is a photograph of the once-elegant sitting room in the nurses' residence; this same room is pictured at the bottom of page 41. (Courtesy of Robert L. Williams.)

This photograph of the dining hall shows "No More Jello" graffiti occupying the former location of the WPA mural. A common misconception regarding the mural is that it existed up until the time of the sanatorium's demolition; in fact, the work of art had been destroyed almost 40 years earlier during a major dining hall renovation in the 1950s. (Courtesy of Bill Minnich.)

This is a view of a curiously placed postural dependency bed in the kitchen. Postural dependency treatment was bed rest with the position carefully selected to cause bacteria to seep away from diseased areas of the lungs, allowing for infected cavities to heal and close when collapse therapies such as pneumothorax and thoracoplasty failed. It was felt that the advantages of this procedure far outweighed the extreme discomfort of lying in an unusual position.

The photograph above shows the sanatorium's trashed semi-ambulant ward, and below is its graffiti-scarred chapel. Both of these images are from the late 1980s. By this time, the abandoned hospital had become a mecca for partygoers and local teenagers, who referred to it as "the bin," "the asylum," or "Overbrook," believing that it had once been part of the psychiatric center located down at the base of the mountain. Although the two institutions were in close proximity of one another, they were completely separate facilities.

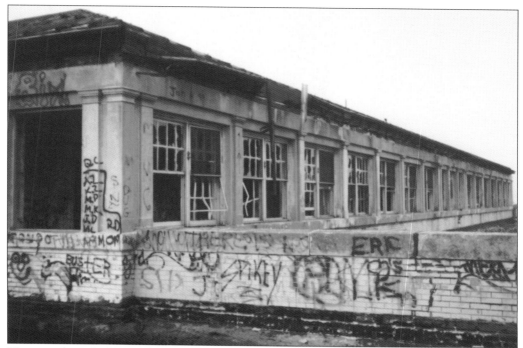

This view from the Hospital Building's western heliotherapy deck shows what all the years of neglect and vandalism had done to the institution by the early 1990s. These rooms were once part of the sanatorium's heliotherapy department, with their special Vita Glass long since smashed. This is the same location seen in the photographs on page 83. (Courtesy of Robert L. Williams.)

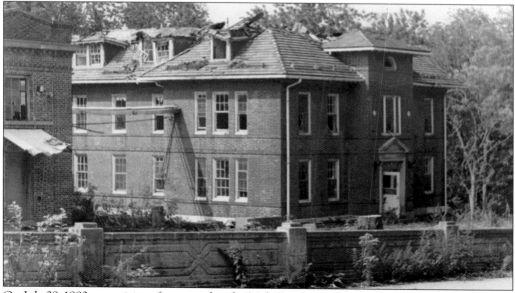

On July 29, 1993, a suspicious fire started at the Male Employee Home, which had been abandoned by Turning Point in 1991. Due to low water pressure and only one functioning hydrant, firefighters battled the blaze for nearly six hours. Part of the structure needed to be torn down, making it the first building of the complex to be destroyed. (Courtesy of Robert L. Williams.)

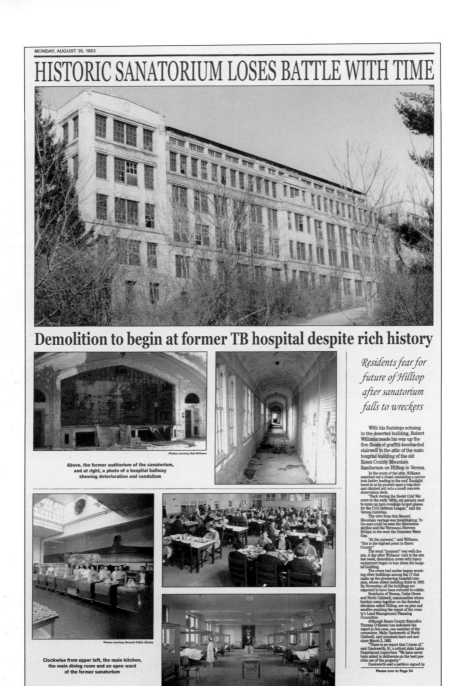

The sanatorium complex was eligible under Criterion A and C for inclusion in the National Register of Historic Places. Criterion A states that a property may be registered if it is associated with events that have made a significant contribution to the broad patterns of history. Under Criterion C, a property may be registered if it embodies the distinctive characteristics of a type, period, or method of construction. Although the sanatorium buildings were deemed safe and structurally sound, rebuilding them for other uses was financially prohibitive and historical preservation was not considered to be an option.

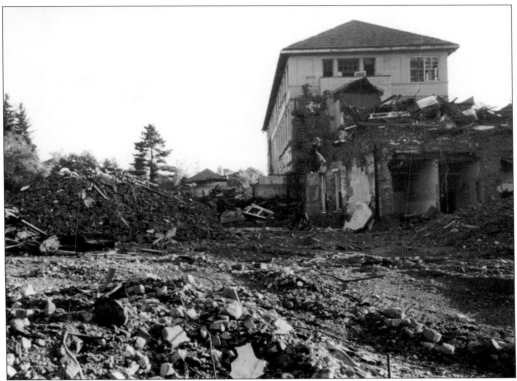

Consequently, razing of the main sanatorium complex began in August 1993. The above photograph shows the remains of the Administration Building, which was the original Newark City Home cottage, the first structure constructed on the property in 1901. The image below was taken from the main parking area and shows the overgrowth has been cut away from the Infirmary, preparing it for demolition. (Both, courtesy of Bill Minnich.)

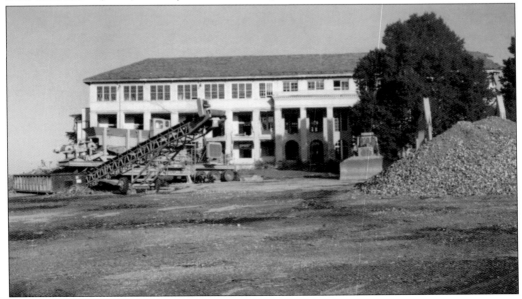

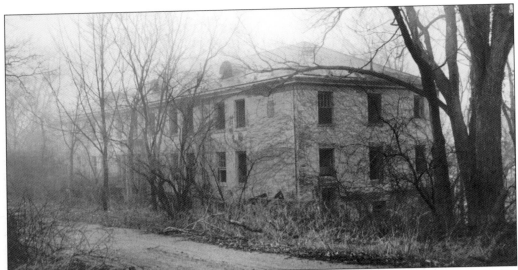

A few of the outer buildings of the sanatorium complex were spared in the demolition of 1993, with structures such as the Female Employee Home (pictured), the Medical Staff Building, and the industrial buildings standing for nearly another decade. The Female Employee Home was a victim of an arson attack in June 2001. The lack of working hydrants caused the fire to burn for more than three hours, effectively collapsing the roof and destroying the building. Compare this photograph with the one on top of page 45.

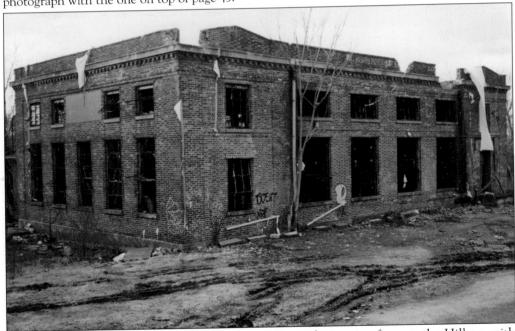

Town meetings were held to address the trespassing and recurring fires on the Hilltop, with local residents and fire officials calling for the destruction of the buildings. In response to the complaints, Essex County increased patrols, hired security guards, and began demolition of the remaining structures, which included the boiler house and the laundry building (pictured), in August 2001.

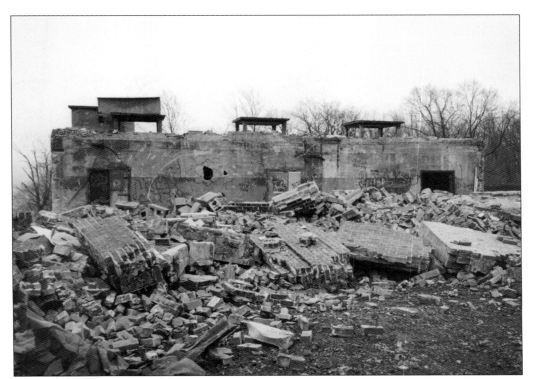

Asbestos removal and demolition continued throughout the winter, and in the early morning hours of April 10, 2002, the last section of the boiler house (pictured)—the final building standing on the property—was destroyed. Destruction of the historic hospital was now complete, and the sanatorium passed silently into history.

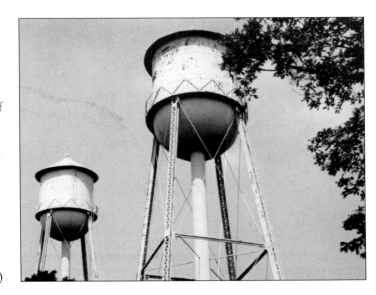

Demolition concluded with the toppling of the institution's two iconic water towers, which removed the last vestiges of a bygone era. In one of the largest public land deals in northern New Jersey, Essex County officials accepted a $60 million contract for private development of the Hilltop and received another $7.9 million from the state's Green Acres program to preserve a portion of the land. (Courtesy of John Lefferts.)

On May 22, 2002, a ceremony dedicated the former sanatorium grounds as the new Hilltop Reservation, and 240 acres of the property was acquired as part of Essex County's park system, protecting the land from future development and ensuring that this oasis in densely populated Essex County be preserved as green, open space. The gates, which had been closed for 20 years, were unlocked, and the Hilltop was opened to the public. For the first time in over 100 years, Second Mountain stood empty, as though a century of time had been erased. It is here that the Essex Mountain Sanatorium's story truly ends. In 1993, the World Health Organization declared tuberculosis a global health emergency, estimating that one third of the world's population has been

ected, with new infections occurring at a rate of about one per second. Hopes that the disease uld be completely eliminated were dashed in the 1980s with the increase of HIV-associated erculosis and the emergence of drug-resistant strains. In 2007, there were an estimated 13.7 lion chronic active cases globally, while in 2010 there were an estimated 8.8 million new cases d 1.5 million associated deaths. Today, totally drug-resistant tuberculosis (TDR-TB), which s first observed in 2003, has an estimated cure rate of only 30 percent and is resistant to all rently used drugs. (Courtesy of John P. McClellan.)

DISCOVER THOUSANDS OF LOCAL HISTORY BOOKS FEATURING MILLIONS OF VINTAGE IMAGES

Arcadia Publishing, the leading local history publisher in the United States, is committed to making history accessible and meaningful through publishing books that celebrate and preserve the heritage of America's people and places.

Find more books like this at
www.arcadiapublishing.com

Search for your hometown history, your old stomping grounds, and even your favorite sports team.